LEGENDARY LOCALS

— OF —

SAVANNAH

GEORGIA

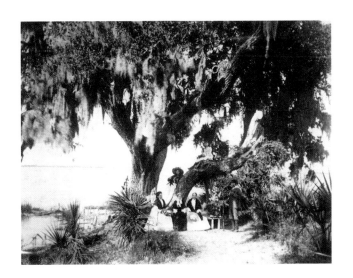

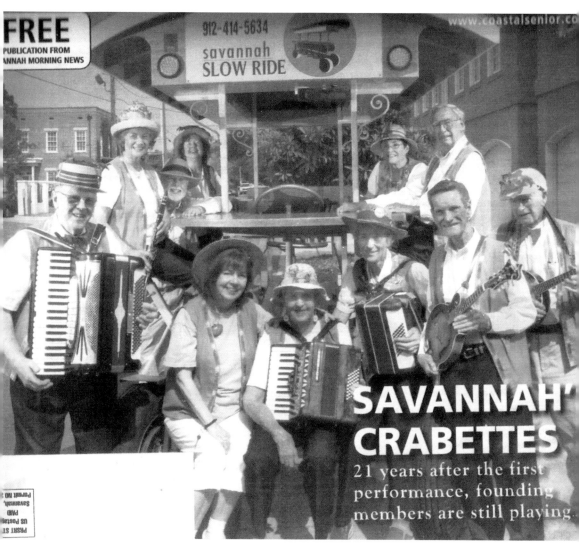

SAVANNAH' CRABETTES
21 years after the first performance, founding members are still playing.

The World-Famous Crabettes
A few ladies got together 25 years ago to play music, wearing straw hats and crabs on their heads. They were described as the Crabettes, and the name continued after they were joined by a few male musicians. They can be spotted frequently around Savannah, playing at parties or nursing homes and riding a float in the St. Patrick's Day parade. (Courtesy of David Watts.)

Page 1: The Habersham Family at White Bluff
The Habersham family has lived in Savannah for eight generations, although the fourth and fifth generations, pictured here, were the last to carry the name. James Habersham arrived from England in 1738 with his friend George Whitefield, and together they established Georgia's first orphanage, Bethesda, which still operates today. The family's export business shipped the first cotton from Georgia. (Courtesy of Lisa Raffetto.)

LEGENDARY LOCALS
OF

SAVANNAH

GEORGIA

LAURA C. LAWTON

Legendary Locals is an imprint of Arcadia Publishing
Charleston, South Carolina

Printed in the United States of America

Library of Congress Control Number: 2014951248

For all general information, please contact Arcadia Publishing:
Telephone 843-853-2070
Fax 843-853-0044
E-mail sales@arcadiapublishing.com
For customer service and orders:
Toll-Free 1-888-313-2665

Visit us on the Internet at www.arcadiapublishing.com

Dedication
To Polly Wylly Cooper
The best friend anyone could have—and the most fun

On the Front Cover: Clockwise from top left:
James Edward Oglethorpe, founder of the colony (Courtesy of the Oglethorpe Club; see page 10), Emma and Lee Adler, pioneers in historic preservation (Courtesy of Emma Adler; see page 91), Johnny Mercer, Savannah songwriter, with his daughter Mandy and niece Nancy (Courtesy of Armstrong State College Library; see page 114), Susie King Taylor, escaped from slavery and nursed soldiers during the Civil War (Courtesy of the Library of Congress; see page 55), Judge Peter Meldrim, mayor of Savannah (Courtesy of Anna Habersham Wright; see page 60), Ben Tucker, Savannah jazz musician (Courtesy of Gloria Tucker; see page 111), Mary Helen Ray, Savannah horticulturalist (Courtesy of Patricia Ray; see page 110), Juliette Gordon Low, founder of the Girl Scouts (Courtesy of the Juliette Gordon Low Birthplace; see page 72), W.W. Law, civil rights leader (Courtesy of City of Savannah, Research Library and Municipal Archives; see page 93).

On the Back Cover: From left to right:
Mills Bee Lane IV, publisher, historic preservationist, and founder of the *Beehive Press* (Courtesy of the Beehive Foundation; see page 89), Rev. F. Bland Tucker, rector of historic Christ Episcopal Church in downtown Savannah (Courtesy of Christ Church Episcopal; see page 75).

CONTENTS

ACKNOWLEDGMENTS

I would like to acknowledge all the people who loaned me books and photographs and all the people who had great suggestions of personalities to write about. I wish I could have included them all. Thanks to the people and organizations who helped, including Katherine Keena at the Juliette Low Birthplace; Beth Moore at the Telfair Museum of Art; Scott Smith at the Coastal Heritage Center; Donna Adamson at the Harper Fowlkes House; Tom Kohler at Chatham-Savannah Citizen Advocacy; Gary Arthur and Gene Carpenter at the Beehive Foundation; David Kelley at Cowart Architects; Allison Rhodes at Savannah Country Day School; Wendy Melton at the Ships of the Sea Museum; Luciana Spracher at the City of Savannah; and Susan Newton at the Winterthur Museum in Delaware. And I would like to thank all the people who brought me photographs and ideas, including Hugh Golson, Rev. Charles Hoskins, Elizabeth Piechocinski, Jean Schley Campbell, Chloe Fort, Michael Hildreth, Robbie Harrison, Howard Morrison, Polly Cooper, and Ted Eldridge. I especially want to thank my editor Erin Vosgien at Arcadia Publishing for patiently holding my hand every day for the year that I worked on this project. I hope we get to meet some day.

INTRODUCTION

It was Polly Cooper who asked me to write this book, but that is not why it is dedicated to her. We have been best friends since we were neighbors in Ardsley Park, three blocks apart. Polly's mother decided girls should all become good tennis players, so she taught a group at Daffin Park. My mother signed me up.

Polly was good at basketball, tennis, and softball, but she did not mind playing with other girls who were not as good. That was just one of her good qualities. When her mother commissioned Eli Dilwood, an older black man, to make a pushmobile for Polly, I was thrilled to spend all my time at her house. It rolled on skate wheels and had a comfortable seat, and you could steer it with your feet. I pushed Polly on it many times around the block, but she always gave me extra rides around.

Polly's family went to the Shack on many weekends, sometimes to spend the night. Her parents and grandparents had Polly and her younger brother and sister as well as cousins to deal with, but they always managed to have room for me. Polly and I would wake up early, catch the horses, and spend the whole day riding.

One of the pleasures of growing up in Savannah was spending the weekends at old family country places. The Shack was anything but the ramshackle structure the name implies. The inside was more like a British hunting lodge, with the interior pine polished like the hull of a ship. The huge fireplace crackled and gave out enough heat to warm everyone on the coldest days.

Our country place was White Bluff, just beyond the outskirts of the city. My grandmother lived there with her sister and her sister's husband, in the same house where she had been raised by her grandparents. The old house had big porches all the way around and plenty of bedrooms upstairs and in the attic. The house overlooked the Vernon River, and the tides ebbed and flowed along with the stories the two old ladies used to tell from their rocking chairs on the porch.

In writing this book, I begin with the founding of our 13th colony, because our founder, James Oglethorpe, planted the seed of altruism for succeeding generations upon his arrival from England. *Non sibi sed aliis* (Not for themselves but for others) was established as the motto for Georgia, and James Oglethorpe lived his life accordingly. He pitied a friend who was imprisoned because he could not pay his debts and later died in prison. As a member of Parliament, Oglethorpe enabled many who had committed no crime but were burdened with debt to be released from prison and begin a new life. Although no prison debtors were actually selected as Georgia colonists, they were all adventurers who were ready to begin a new life, and each had certain skills that would be useful in a new land.

James Oglethorpe held the philosophical view that a community of people who cooperated as equals would create a better colony than if there were social strata as in England. He knew the colony of South Carolina had plantation owners and slaves, and he did not want that system. One of his rules for the new colony was no slaves, and it was not so much that he saw slavery was wrong as it was that it contradicted his idealistic egalitarian views. Also, he wanted every colonist to work hard and create a good home and garden for his or her family. He was afraid that slavery might discourage hard work among the slave owners. These concerns also inspired his second rule—no rum. He did not want the colonists drinking rum instead of working. And his third rule was no lawyers. If citizens were equal, people could talk things over, and there was no reason to go to court.

An important purpose that Oglethorpe and the trustees had in mind for the colony was to create a buffer between South Carolina and the Spanish to the south. Oglethorpe's military experience in England had prepared him well to train the colonists to defend their colony. He was prepared to deal successfully with both the Spanish and the Native Americans. Although he had to defeat the Spanish threat militarily, he eliminated what could have been a Native American threat with his diplomatic skills. Fortunately, Chief Tomochichi, who greeted him, was as skilled as Oglethorpe in diplomacy and good will.

From Oglethorpe and Tomochichi to the present-day folks in the last chapter, you will meet many of the people who have contributed to our community. I admire all of them, and you will too. There are so many more interesting people; I wish I could profile them all. The only answer is for you to come to Savannah and see why we love living in this place with these amazing people.

CHAPTER ONE

Early Georgia Settlers

Today Savannah is a bustling city with tourists and local residents walking around in the historic district, enjoying the shops on the riverfront, and touring the museums. It is a huge contrast to the riverbank of 1733 when James Oglethorpe arrived with 114 colonists aboard a small ship from England. Oglethorpe was a man of generosity and idealism, and he rightly deserves the title of Georgia's founder.

James Oglethorpe was a member of Parliament and a friend of Robert Castell, a well-known architect who had produced a book of engravings of examples of architecture from all over the world. The book was expensive to publish, and Robert Castell was put in prison for not paying his debts. After Castell died in prison from smallpox, Oglethorpe became interested in prison reform. He managed to get an act passed freeing many debtors from prison, but many were faced with unemployment. Oglethorpe came up with the idea that they could have a new start by helping to settle the new colony of Georgia.

In 1730, Oglethorpe and his friends in Parliament made a proposal to King George that they would become trustees for a piece of land south of Carolina. When the trustees received permission to establish the new colony, they began to interview prospective colonists. Each man had to be a soldier and a planter. The trustees agreed to provide weapons for defense, tools for planting, and 50 acres of land per family. Women were not allowed to serve on juries, act as soldiers, or inherit land. Only Protestants were allowed to go, as the trustees feared the Catholic threat from the Spanish and French.

Not only were Catholics banned from the new colony but also slaves, lawyers, and rum. Beer and wine were allowed, however. When the trustees interviewed applicants to be selected as colonists, they did not just select anyone who was released from prison. Oglethorpe and the trustees made sure that the first colonists had permission from their creditors to go, if they were in debt, and they had to be recommended by their clergyman.

Life was not easy for the early colonists, but they worked hard and cleared the land to build houses. Oglethorpe's plan was followed from the beginning, and future generations held to the established grid of streets and squares. The result of his excellent plan is the nationally recognized historic district of the city of Savannah today.

James Edward Oglethorpe

James Oglethorpe is the founder of the Georgia colony. Oglethorpe sailed from England with 114 colonists aboard the ship *Ann* to found the new colony of Georgia in 1733. Although he stayed in Savannah only 10 years, he provided the leadership the colony needed in its beginning. Oglethorpe did not approve of the class divisions he saw in England, and he wanted everyone in the new colony to be equal. This was one of his reasons for prohibiting slavery in Georgia in the early years. (Courtesy of the Oglethorpe Club.)

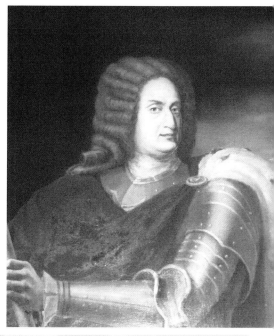

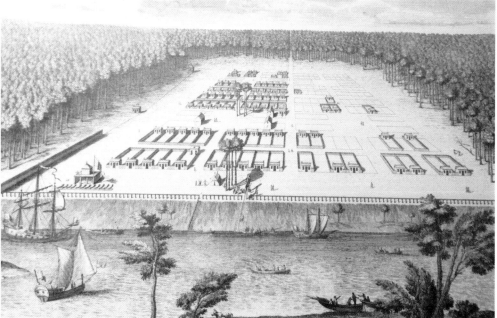

Oglethorpe's City Plan

Savannah is one of the first planned cities in America. Oglethorpe arrived in the Savannah area with a design for a city that would prove an excellent one for many generations. The plan included streets and squares in a grid design, which provided green space surrounded by trust lots for buildings of common interest and tithing lots for families. Each tithing lot was exactly the same size as every other so that no one person would be more powerful than another. (Courtesy of V&J Duncan Antique Maps, Prints & Books.)

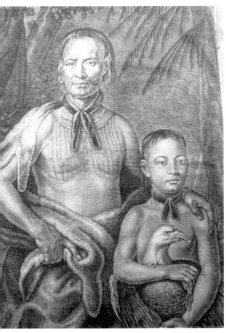

Tomochichi and His Nephew Toonahowi
Chief Tomochichi was an asset to Oglethorpe and the colonists. Tomochichi was the Yamacraw Indian chief who greeted Oglethorpe and the colonists when they arrived from England in 1733. He and Oglethorpe became friends, and Oglethorpe took Tomochichi and his family back to England on one of his trips. There was a good deal of excitement when the Native Americans were presented to Parliament. (Courtesy of V&J Duncan Antique Maps, Prints & Books.)

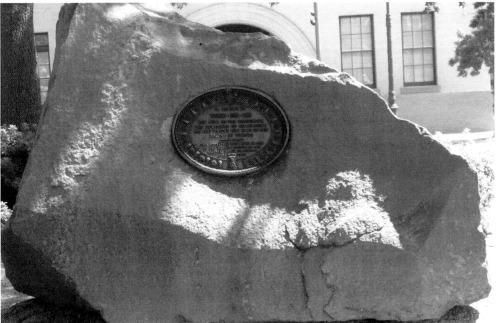

Tomochichi's Boulder
This granite boulder was placed in Wright Square in memory of Tomochichi. When Tomochichi died in 1739, he had asked to be buried with his new friends in the colony. Oglethorpe served as a pall bearer at his funeral. Today an enormous granite boulder stands in Wright Square as a memorial to the chief of the Yamacraws who was instrumental in the survival of the Georgia colony. The plaque on the boulder indicates the memorial was placed there by the Colonial Dames of America in the State of Georgia. (Courtesy of the author.)

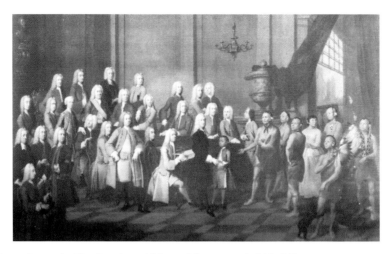

Native Americans in England and Mary Musgrove's Wedding

Mary Musgrove's husband, John Musgrove, accompanied Oglethorpe and the Creek Indians to England. Later, Mary married Thomas Bosomworth.

Mary Musgrove was born some time around 1700 in a Creek Indian village to a Creek mother and an English trader, Edward Griffin. She was considered a Native American and spoke the Creek language, but she also learned English and the customs of Colonial American society.

In 1717, she married John Musgrove, and together they set up a trading post at the site where the Georgia Port Authority is now. Mary helped her husband as an interpreter and used her connections to help her husband in business.

John Musgrove and a group of Creek Indians accompanied Oglethorpe to England, and John was given some land at Yamacraw Bluff on the edge of the Savannah River. He died in 1735, and Mary ran the trading post and became an interpreter for Oglethorpe and the Creek Indians. Her work interpreting between Oglethorpe and Tomochichi encouraged the peaceful founding of the new colony of Georgia.

Mary married a second time, and after he died in 1742, she married Rev. Thomas Bosomworth. This marriage gave her a high status in the community, and the couple entertained Creek and American guests in their home. Later, Mary was given several barrier islands, but after a dispute with the royal governor Henry Ellis, she was allowed to keep only one, St. Catherine's Island. (Above, courtesy of the Winterthur Museum, gift of Henry Francis duPont, 1956.567; below, courtesy of V&J Duncan Antique Maps, Prints & Books.)

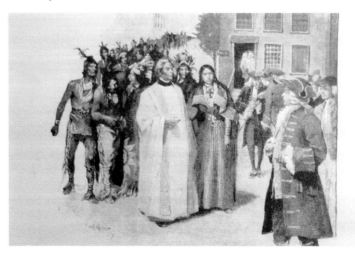

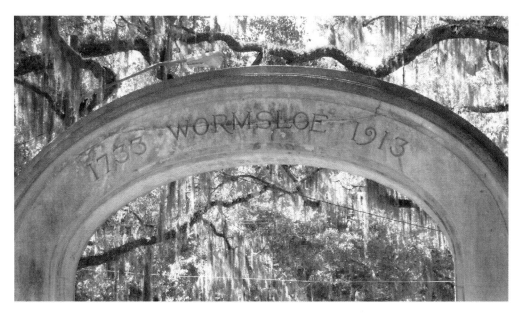

Noble Jones

Wormsloe Plantation was the home of Noble Jones and an original land grant from King George II. He bequeathed the land to Noble Jones, who sailed from Gravesend, England, and arrived in Savannah in 1733 with his wife and family. Jones received 500 acres about 10 miles south of Savannah at Isle of Hope. The plantation, Wormsloe, is still owned by the same family, and the entrance and visitor center are open to the public. (Courtesy of the author.)

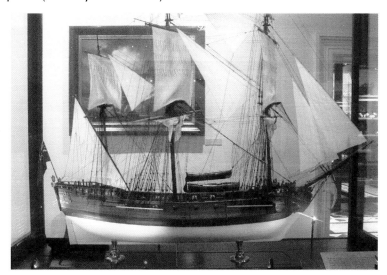

The Ship *Ann*

The ship *Ann* was only 87 feet long and 26 feet wide. Noble Wimberly Jones was only 10 years old when he arrived with his parents and younger sister along with Oglethorpe and the other colonists to found the 13th colony of Georgia in 1733. The voyage from England was harsh and difficult, with 114 colonists crowded together with limited food rations. The trip took two months before the 40 families were able to land in Charles Towne (later Charleston), South Carolina, and travel on to Savannah. (Courtesy of the Ships of the Sea Museum.)

Noble Wimberly Jones

The Georgia Medical Society honored Noble Wimberly Jones as its first president. Jones learned to practice medicine with his father and formed the Georgia Medical Society in 1804. He was one of Georgia's Liberty Boys, who met in Tondee's Tavern on Broughton Street and planned the Revolution. He loved practicing medicine and actively did so until his death in 1805 at age 82. (Courtesy of the author.)

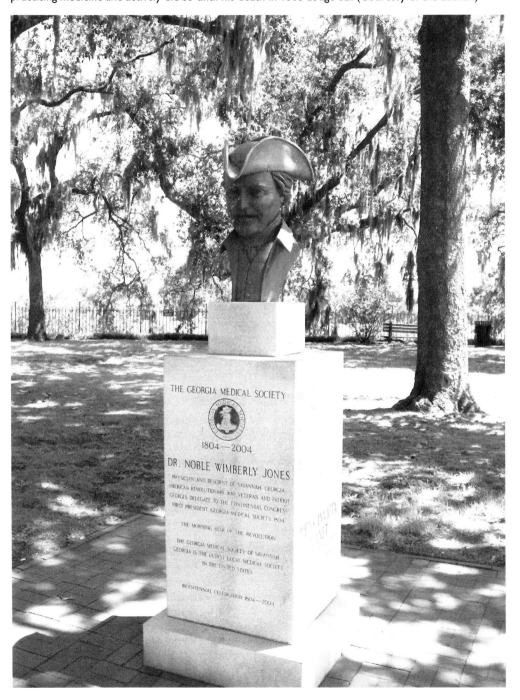

James Habersham
James Habersham shipped the first cotton from Georgia to England. Habersham was born in 1715 in Beverley, Yorkshire, England. His mother died when he was only seven years old, and his father died when he was 13. He moved to London and learned the skills of a merchant in the midst of the bustling commercial activity on the Thames. (Courtesy of Jackson Connerat.)

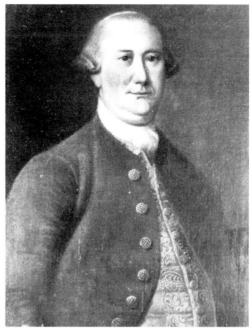

Bethesda
Bethesda is the oldest childcare institution in America still in continuous operation. James Habersham sailed to Savannah in 1738 with George Whitefield to start an orphanage, and they founded Bethesda. Habersham was its first teacher and administrator, while Whitefield preached all up and down the East Coast, raising money for the orphanage. (Courtesy of the author.)

Habersham Memorial Window
Habersham was honored by the Colonial Dames of America in the State of Georgia for his work with orphans. James Habersham and Mary Bolton were married at Bethesda by George Whitefield in 1740. Of their 10 children, only three survived to adulthood, and all three went on to lead distinguished lives in colonial Georgia. Habersham left the orphanage and started a firm that shipped the first cotton from Georgia, and he became one of the wealthiest men in Georgia. He is remembered in a memorial window in the chapel at Bethesda. (Courtesy of the author.)

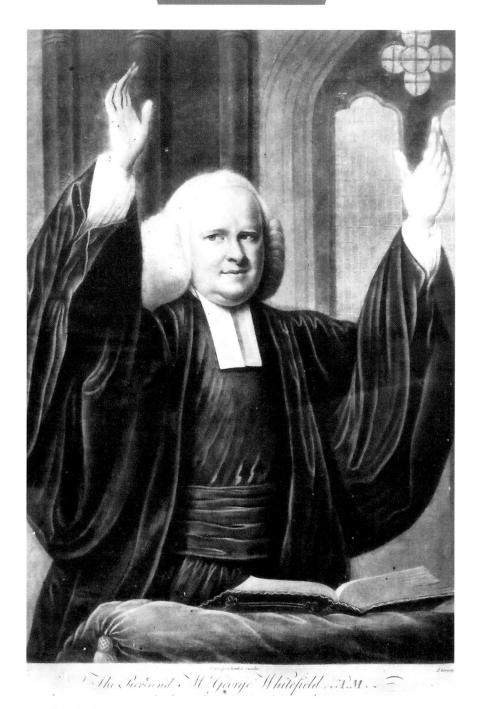

The Reverend M^r George Whitefield A.M.

George Whitefield

George Whitefield is remembered as the founder of Bethesda and a revivalist. Whitefield was born in Gloucester, England, in 1714 and attended college at Oxford, where he was influenced by the brothers John and Charles Wesley. He became inspired to become an evangelist and devote his life to preaching the word of God. He sailed to Savannah in 1738 aboard the ship *Whitaker* with his friend James Habersham to found the orphanage called Bethesda. (Courtesy of Alex Knox.)

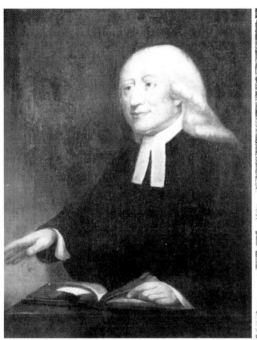
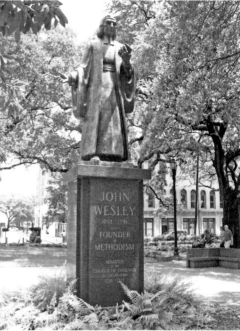

John Wesley

John Wesley was honored with a statue given by the Methodists of Georgia. He is remembered at Christ Church Episcopal in downtown Savannah. Wesley was born in England and ordained a priest there in 1728. He came to Savannah in 1736 at the request of James Oglethorpe to be a priest at Christ Church on Johnson Square. Wesley's initial goal was to evangelize the Native Americans, but he was also needed to minister to Anglicans at their church in the new colony.

John and his brother Charles, who had written many religious songs, compiled the first book of hymns, and the text was widely used in both England and the Colonies. Wesley stayed only two years in Savannah, mostly because of a problem that arose after he fell in love with a young woman named Sophie Hopkey. She married someone else, and he passed over her when she came to the communion rail. After he left Savannah, he preached in England and organized others to form the Methodist Church. (Above left, courtesy of Christ Church Episcopal; above right and below, courtesy of the author.)

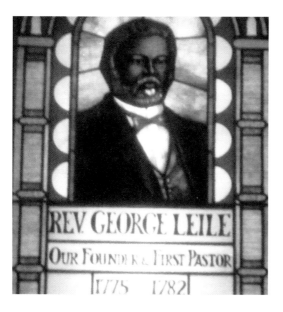

Rev. George Leile

Rev. George Leile was the first black Baptist preacher in Georgia. Leile was born a slave in Virginia and came to Georgia in 1773. He was the first pastor of First African Baptist Church in Savannah. He preached to the slaves at a plantation in Silver Bluff, South Carolina, and taught them to sing hymns, explaining the meaning of the words. His small congregation of 30 people is considered to be the oldest black congregation in North America. (Courtesy of the author.)

Rev. Andrew Bryan

Rev. Andrew Bryan belongs to both First African and First Bryan Baptist Churches. Bryan was born a slave on a plantation in Goose Creek, South Carolina, in 1737. In 1765, he came to Brampton, Jonathan Bryan's plantation on the Savannah River, where he was given an old rice barn that could be used for community gatherings. It was here that George Liele preached and baptized Andrew Bryan and his family in 1783. Bryan bought land and built a church where First Bryan Baptist Church stands today. (Courtesy of the author.)

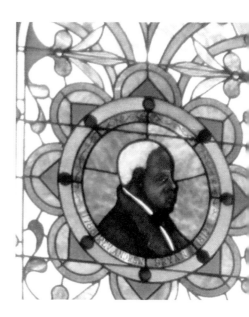

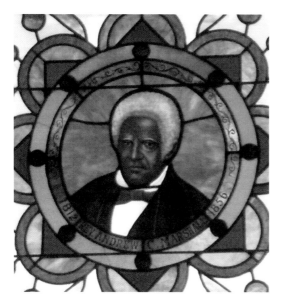

Rev. Andrew Marshall

Rev. Andrew Marshall was the third pastor at First African Baptist Church. Under his leadership, the church obtained the property where the present sanctuary stands. He organized the first black Sunday school in North America and changed the name of the church from First Colored Baptist to First African Baptist Church. He is buried in Laurel Grove South Cemetery with other black church pastors. (Courtesy of the author.)

CHAPTER TWO

Revolutionary Patriots

Georgia was a royal province, with a royal governor appointed by the King George II. John Reynolds was the first royal governor in 1754, followed by Henry Ellis in 1757. Governor Ellis did a good job of managing relations with the Creek Indians in spite of the difficulties brought about by the French and Indian War. Governor Ellis left Georgia functioning in a much better condition than he had found it. He was followed by the third and last royal governor, James Wright. Governor Wright's administration lasted for 16 years, from 1760 to 1776, during the difficult time that the flames of revolutionary fervor were stirred up in the Georgia colony.

The year that James Wright became governor was 1760, the year that George III succeeded his grandfather George II. Governor Wright was an intelligent and fair leader, respected by almost all the people of Georgia. However, as revolutionary fervor rose, his loyalty to England put him at conflict with his own Georgia Assembly.

In 1769, Georgians who opposed what they felt were unfair British taxes organized in protest. Following the lead of other British colonies, they called themselves the Liberty Boys. Jonathan Bryan presided at the first meeting; he had come to Georgia from South Carolina and lived at Walnut Hill Plantation. He was just a boy in Pocotaligo, South Carolina, when his father came over with Col. William Bull to help Oglethorpe choose a site for the colony.

In 1771, James Wright went to England on a leave of absence, and James Habersham was appointed president of the council. He agreed with the Patriots in theory, but he remained a Loyalist until his death in 1775. Governor Wright returned from England in 1773, but the Liberty Boys were now meeting regularly at Tondee's Tavern in secret to plot their strategy, which led to the American Revolution. Peter Tondee died in 1775, but his wife kept the tavern open. The first reading in the colony of Georgia of the Declaration of Independence took place there on August 10, 1776. It was read by Archibald Bulloch, and it had been signed by three Georgians: Button Gwinnett, George Walton, and Lyman Hall. The declaration was subsequently read in Johnson Square and several other places. The people of Savannah yelled and cheered and fired a cannon along the banks of the Savannah River.

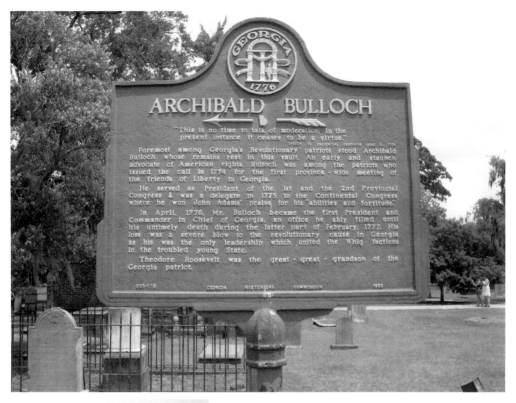

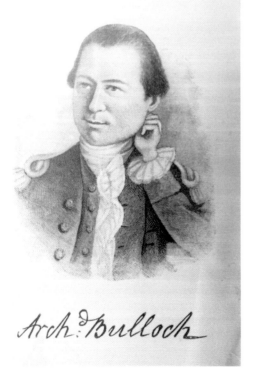

Archibald Bulloch

Archibald Bulloch was a lawyer, soldier, and statesman during the American Revolution, and he was born in Charles Towne, South Carolina, in 1730. He practiced law in Charles Towne until his family came to Savannah in 1758. Bulloch was one of the Liberty Boys who met at Tondee's Tavern in 1775 to plan for the revolution against the British. The Provincial Congress of Georgia elected Bulloch its president, and he was also selected a delegate from Georgia to the First Continental Congress. When he arrived in Washington, he impressed the other delegates by wearing homespun clothes, symbolizing Georgia's commitment to the embargo on British goods.

Bulloch fought in the American Revolution under Lachlan McIntosh in the Battle of the Rice Boats. In 1776, he was entrusted with leading a dangerous expedition to Tybee Island. Bulloch and his men destroyed British facilities and killed and captured British marines. He was elected commander in chief of Georgia, serving as its first president under the new republican government. He held that post until he died in 1777. (Above, courtesy of the author; left, courtesy of V&J Duncan Antique Maps, Prints & Books.)

Casimir Pulaski

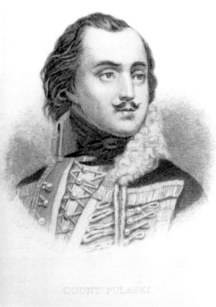

COUNT PULASKI.

Casimir Pulaski is one of Savannah's Revolutionary War heroes who gave his life in the Battle of Savannah in 1779. Pulaski came to America in 1777 to support the colonists in their struggle against the British. He commanded the whole cavalry on October 9, 1779, at the siege of Savannah, where he was mortally wounded at the age of 34. His wounded body was taken on the day of battle to a ship, the merchant brigantine *Wasp*, and he died two days later. There is some question as to whether he was buried at sea or taken to Greenwich Plantation to buried, where his supposed remains were later exhumed and reburied under the monument in Monterey Square.

This plaque stands in Monterey Square near the Pulaski monument. In 1996, the monument was restored, and the human remains found underneath were exhumed. The DNA was compared to the DNA of Pulaski cousins in Poland, but the results were inconclusive; the remains were reinterred in the square in 2005 in a ceremony with full military honors. Fort Pulaski is named after him. (Left, courtesy of V&J Duncan Antique Maps, Prints & Books; below, courtesy of the author.)

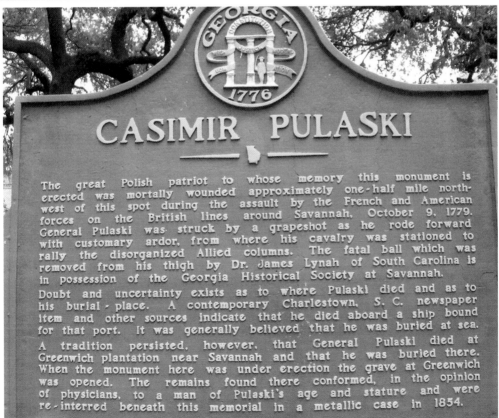

CASIMIR PULASKI

The great Polish patriot to whose memory this monument is erected was mortally wounded approximately one-half mile north-west of this spot during the assault by the French and American forces on the British lines around Savannah, October 9, 1779. General Pulaski was struck by a grapeshot as he rode forward with customary ardor, from where his cavalry was stationed to rally the disorganized Allied columns. The fatal ball which was removed from his thigh by Dr. James Lynah of South Carolina is in possession of the Georgia Historical Society at Savannah.

Doubt and uncertainty exists as to where Pulaski died and as to his burial-place. A contemporary Charlestown, S. C. newspaper item and other sources indicate that he died aboard a ship bound for that port. It was generally believed that he was buried at sea.

A tradition persisted, however, that General Pulaski died at Greenwich plantation near Savannah and that he was buried there. When the monument here was under erection the grave at Greenwich was opened. The remains found there conformed, in the opinion of physicians, to a man of Pulaski's age and stature and were re-interred beneath this memorial in a metallic case in 1854.

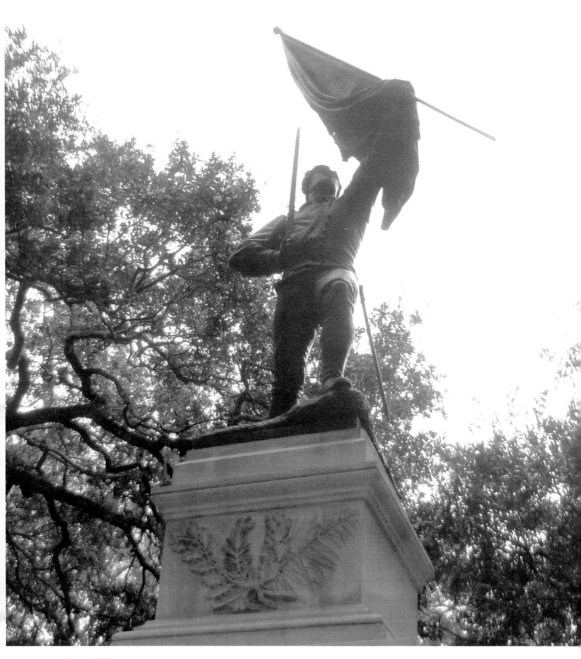

Sgt. William Jasper
Sgt. William Jasper heroically defended the American flag. Jasper was a Revolutionary War hero killed while attempting to rescue the colors of his regiment. He was part of the 2nd Regiment of South Carolina Continentals, who came to support the Patriots attempting to take back the city of Savannah from the British in 1779. The Battle of Savannah was one of the bloodiest battles of the American Revolution. Sergeant Jasper is remembered with a handsome monument in Madison Square on Bull Street. (Courtesy of the author.)

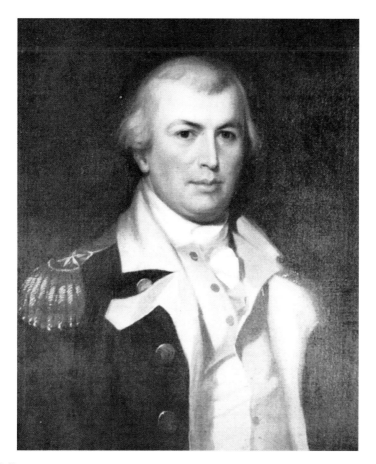

Nathanael Greene

Nathanael Greene, a friend of George Washington, was born into a family of Rhode Island Quakers in 1742. He was discouraged from both academic and military life as a child, but these were his primary interests as an adult. Just before his father's death, Greene moved to Coventry, Rhode Island, to operate his father's foundry. Here he was the first to urge the establishment of a public school.

Greene was chosen as a member of the Rhode Island General Assembly, with which he served for several years. In 1774, he married Catherine "Caty" Littlefield Greene, and they had six children. Greene organized a militia and studied the art of war, in spite of the fact that this went against his Quaker upbringing. He read books on military tactics and taught himself in spite of his own pronounced limp. After the siege of Boston by the British in 1775, he was promoted from private to general in the Rhode Island Army.

George Washington put Greene in charge of the city of Boston in 1776. Greene fought many battles and supported Washington at Valley Forge in 1778. Greene was a Freemason in Rhode Island, and he carried a Masonic jewel with him throughout the war. The jewel was a gift from his friend and fellow Freemason the Marquis de Lafayette. Washington appointed Greene commander of West Point, but he then called him to be commander of the Southern Army against Cornwallis. Greene was in charge of all troops from Delaware to South Carolina, with Brig. Gen. Isaac Huger from the South Carolina Continentals as his second in command.

After the war, Greene and his family were given a plantation, Mulberry Grove, outside of Savannah. There he died of a sunstroke in 1786 at the age of 43. A monument in Savannah's Johnson Square was built to honor him, and both he and his son are buried beneath it. There are many cities, counties, and parks named for him, as well as other memorials across the country. (Courtesy of the Library of Congress.)

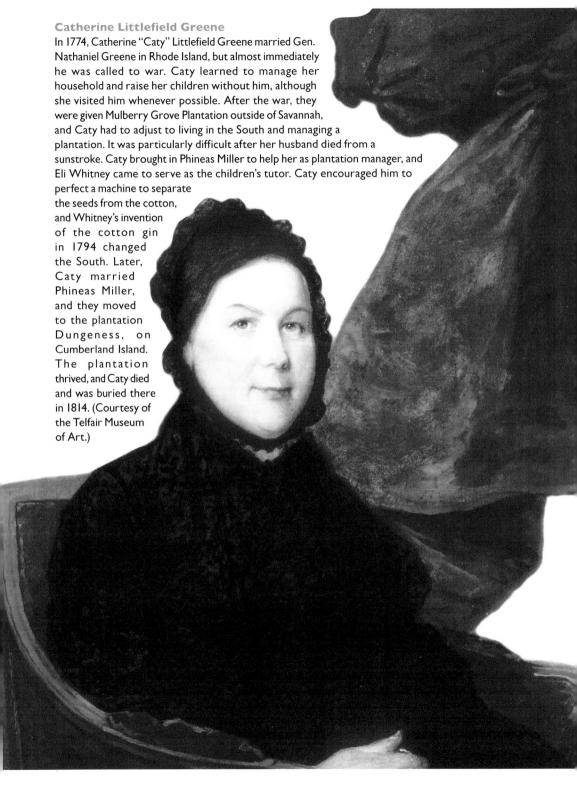

Catherine Littlefield Greene

In 1774, Catherine "Caty" Littlefield Greene married Gen. Nathaniel Greene in Rhode Island, but almost immediately he was called to war. Caty learned to manage her household and raise her children without him, although she visited him whenever possible. After the war, they were given Mulberry Grove Plantation outside of Savannah, and Caty had to adjust to living in the South and managing a plantation. It was particularly difficult after her husband died from a sunstroke. Caty brought in Phineas Miller to help her as plantation manager, and Eli Whitney came to serve as the children's tutor. Caty encouraged him to perfect a machine to separate the seeds from the cotton, and Whitney's invention of the cotton gin in 1794 changed the South. Later, Caty married Phineas Miller, and they moved to the plantation Dungeness, on Cumberland Island. The plantation thrived, and Caty died and was buried there in 1814. (Courtesy of the Telfair Museum of Art.)

24

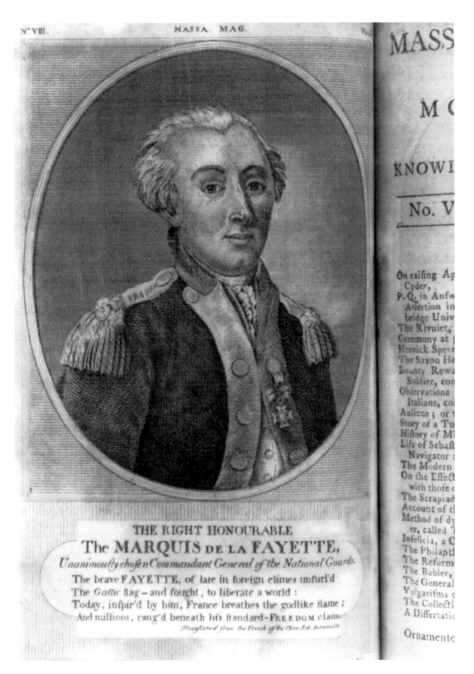

Marquis de Lafayette
In 1825, the Marquis de Lafayette visited Savannah, 50 years after Lafayette fought with George Washington at the Battle of Brandywine. Lafayette was the last surviving Revolutionary War major general when he was greeted upon his arrival in Savannah by a cheering crowd. He disembarked from the ship at the Savannah River dock and made a stirring speech from the balcony of the Owens Thomas House on Oglethorpe Square. Then he laid the cornerstones for monuments to two other Revolutionary heroes, Count Casimir Pulaski in Monterey Square and Gen. Nathanael Greene in Johnson Square. (Courtesy of the Library of Congress.)

Lachlan McIntosh

Lachlan McIntosh was the commander of American forces in Georgia during the American Revolution. He was born in Scotland in 1725 and moved to Georgia with his family in 1736 with a number of other Scottish settlers. They settled south of Savannah at New Inverness, where Darien is today. McIntosh was introduced early on to the dangers of Colonial living when his younger brother was killed by an alligator while swimming in the river. McIntosh's father fought as part of Oglethorpe's militia against the Spanish in the War of Jenkins' Ear. He was captured and held prisoner for two years, and his health never fully recovered. After his father died, Lachlan was sent to Savannah, where he lived at Bethesda Orphanage for two years.

McIntosh moved to Charles Towne in 1748 and took a position as a clerk for Henry Laurens, a wealthy merchant who took an interest in the young man. In 1756, he married Sarah Threadcraft and returned to Georgia to become a planter. McIntosh was commissioned as a colonel in the Georgia Militia, and he organized the defense of Savannah against the British in 1776. He was promoted to brigadier general in the Continental Army.

McIntosh and Button Gwinnett represented opposing factions in the independence movement, and McIntosh insulted him publicly. Gwinnett challenged McIntosh to a duel, and the two men paced off and fired pistols at each other simultaneously. McIntosh was wounded in the leg and Gwinnett in the thigh, but only Gwinnett died from his wounds. McIntosh was charged with murder but acquitted. George Washington, concerned for McIntosh's safety, had him called to the Continental Army headquarters, and McIntosh spent the winter at Valley Forge, where he commanded several regiments of North Carolina troops. McIntosh returned to Georgia with his troops in time to fight at the Battle of Savannah against the British in 1779. He returned to his plantation after the war, but the British had not left much of it. He died in Savannah and is buried in the Colonial Cemetery, not far from his old political rival Button Gwinnett. (Courtesy of the author.)

Button Gwinnett

Button Gwinnett was one of three signers of the Declaration of Independence from Georgia. He was born in England in 1735 and came to Savannah in 1765 by way of Charles Towne. Gwinnett became a merchant and then purchased St. Catherine's Island so that he could become a planter. He became active in local politics and won a seat in the Commons House Assembly in 1769.

Gwinnett was appointed to the Continental Congress, and he served in Philadelphia in 1776. He, along with George Walton and Lyman Hall, was one of the three signers of the Declaration of Independence from Georgia.

As a member of the Whig party, Gwinnett was opposed to the views of Lachlan McIntosh, a popular Georgia legislator. The two men were enemies for quite some time until Gwinnett challenged McIntosh to a duel. Both men shot each other, but only Gwinnett's wounds were fatal. He is buried in Savannah's Colonial Park Cemetery. (Above, courtesy of the author; left, courtesy of the Library of Congress.)

27

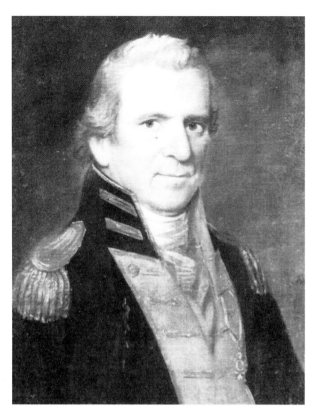

Maj. John Berrien
Maj. John Berrien was wounded in the American Revolution. He was born in 1760 at the family home, Rocky Hill, near Princeton, New Jersey. He came to Georgia in 1775 when the threat from the British was at hand, and he was commissioned a second lieutenant in the 1st Georgia Continental Brigade in 1776. He served under Gen. Lachlan McIntosh and was a firm supporter of his when McIntosh killed Button Gwinnett in a duel. Berrien distinguished himself in the Revolutionary War, and he was promoted to first lieutenant and then captain. (Courtesy of the author.)

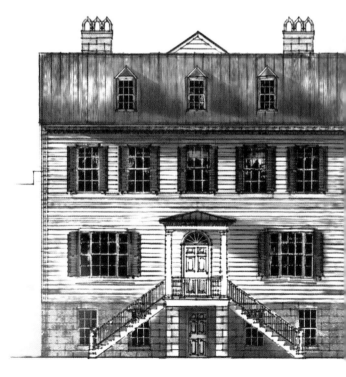

Berrien House
John Berrien's house is one of the few historic homes left on Broughton Street. After the war, Berrien moved to Georgia with his wife, Margaret MacPherson, and his young son John MacPherson Berrien. The home that he built on the corner of Broughton and Habersham Streets was known for its many distinguished visitors. It is being tastefully restored by Berrien's great-great-great-grandson. (Courtesy of David B. Kelley, Cowart Architects.)

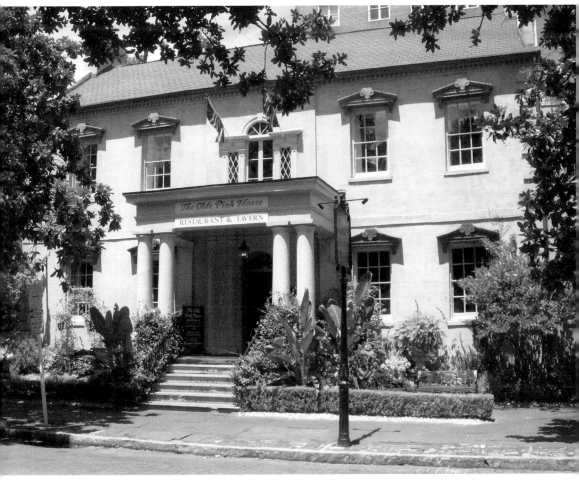

The Pink House

James, Joseph, and John Habersham were three brothers who were the sons of James Habersham, the colonial leader who arrived in Savannah from England in 1737 and his wife, Mary Bolton. All three young men were Revolutionary War Patriots in spite of the fact that their father stayed loyal to the crown until his death in 1775. In 1771, the Pink House was built for James Habersham and his wife, Esther Wylly. Today it is a popular restaurant in the historic district.

James Habersham was more interested in pursuing his father's business interests than in plotting with his brothers as the revolutionary fervor swept through Tondee's Tavern. He supported the cause through his work at Habersham and Harris, his father's firm, which shipped the first cotton from Georgia. He was the rebel financier who supported the Patriots.

His son Richard Wylly Habersham was born in the Pink House and lived in Savannah until his later years, when he retired to Clarkesville, in Habersham County. A Princeton graduate, Richard studied law and was appointed US prosecutor for Georgia. He prosecuted the case of the *Antelope*, a slave ship that was captured and brought to the port of Savannah. (Courtesy of Emily Stewart.)

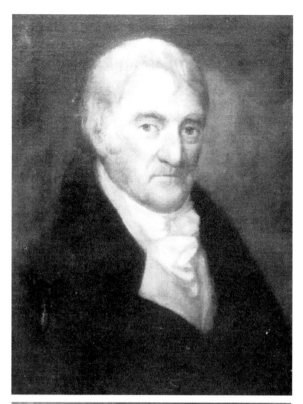

Col. Joseph Habersham
Col. Joseph Habersham was a Liberty Boy and postmaster general of the United States under Pres. George Washington. Habersham was born in 1751 and graduated from Princeton College, entering into the mercantile business with his cousin Joseph Clay. The two men met with the Liberty Boys at Tondee's Tavern and planned strategies against the British. Habersham was a delegate to the Continental Congress in 1785 and mayor of the city of Savannah from 1792 to 1793. Courtesy of Richard W. Adams.)

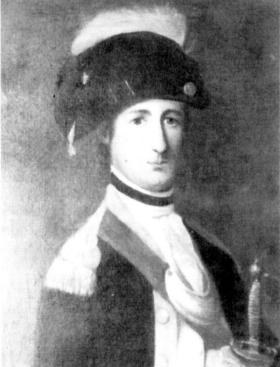

Maj. John Habersham
Maj. John Habersham was a Liberty Boy captured twice during the American Revolution. Habersham was born in 1754 and graduated from Princeton College. He served as a first lieutenant in the Revolutionary War and was twice taken prisoner by the British. Habersham was a member of the Continental Congress in 1785 and appointed as an Indian agent by General Washington. He was a member of the convention that established the Georgia–South Carolina boundary. (Courtesy of Charlotte Raffetto.)

Historic Marker for the Habersham Brothers
The three Habersham brothers, James, Joseph, and John, are buried together with their wives in the
Colonial Cemetery in the historic district of Savannah. Their parents, James Habersham and Mary Bolton,
are interred there also. (Courtesy of Hadley Stewart.)

JOSEPH HABERSHAM (1751-1815)
JOHN HABERSHAM (1754-1799)
JAMES HABERSHAM, JR. (1745-1799)

The three Habersham brothers - who here rest beside their
distinguished father, James Habersham - were prominent patriots in
the American Revolution and outstanding public men during the
early years of the Republic.

JOSEPH HABERSHAM, ardent Son of Liberty and a member of the
Council of Safety, took part in the raid on the King's powder
magazine in 1775, and in 1776 personally accomplished the dramatic
arrest of the Royal Governor, Sir James Wright. He served in the
Revolution as a Lieut. - Col. in the Ga. Continental line; was twice
Speaker of the General Assembly; Mayor of Savannah, 1792-'93; and
Postmaster General of the U. S., 1795 - 1801.

JOHN HABERSHAM, Major in the first Ga. Continental Regt., distin-
guished himself in the Revolutionary War during which he was
twice taken prisoner. He was a member of the Continental Congress
in 1785; Commissioner in the Convention which established the Ga
-S. C. boundary; and first Collector of Customs at Savannah.

JAMES HABERSHAM, JR., merchant, actively opposed the revenue
acts of Parliament in 1775. He served (as did John Habersham) on the
board of Trustees created in 1785 to establish the University o
Georgia, and was Speaker of the General Assembly in 1782 and
in 1784.

025-14 GEORGIA HISTORICAL COMMISSION 1953

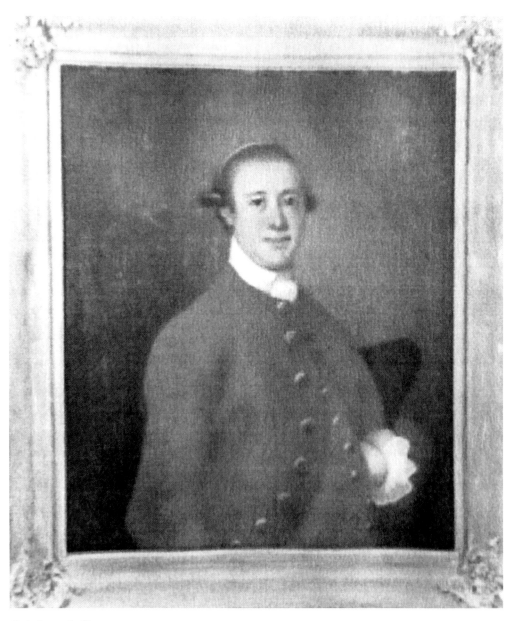

Col. Joseph Clay

Col. Joseph Clay was one of the Liberty Boys who fought in the American Revolution. Clay was born in England and came to Savannah to join his uncle James Habersham in 1760. Habersham encouraged his nephew to go into business with his eldest son, James Habersham Jr., and they became partners in the mercantile business. As the movement for independence increased across the country, Joseph Clay and the Habersham boys began to adopt political ideas that were in opposition to their elders, whom they loved and respected. Joseph Clay joined the Liberty Boys, who met in secret at Tondee's Tavern, and made plans for the revolution against England. After the Revolutionary War, Joseph Clay served as a delegate to the Continental Congress and was one of the trustees who established the college that developed into the University of Georgia. Colonel Clay and his wife, Anne, had 13 children. (Courtesy of the Society of the Cincinnati in the State of Georgia.)

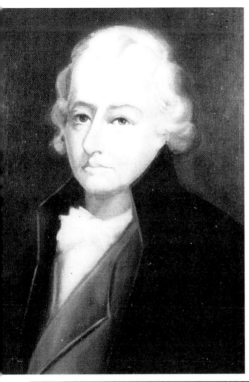

Peter Tondee

Peter Tondee hosted the Liberty Boys at Tondee's Tavern. He was born in England in 1723 and came to Savannah in 1733 on the *James*, the second ship to arrive in the new colony. He traveled with his parents and his five-year-old brother, Charles. They were welcomed by the Native American family Tomochichi, his wife, Senauki, and their nephew Toonahowi, who was the same age as Peter.

After only two months, the boys' father died, and Peter and Charles went to live with Paul Amatis, the Italian silk expert who had come to manage silk production in the colony. Later, they lived with Henry Parker and his family at Isle of Hope, where they worked on the farm; the boys also lived at Bethesda for a time.

Tondee's family owned the building on the corner of Broughton and Whitaker Streets, and he opened a tavern there in 1770. Here the Liberty Boys met in secret to make plans for the revolution against British authority. A plaque on the wall of the building marks the place where Tondee's Tavern stood. Tondee died in 1775, just before the opportunity to see America become a new nation. (Both, courtesy of the author.)

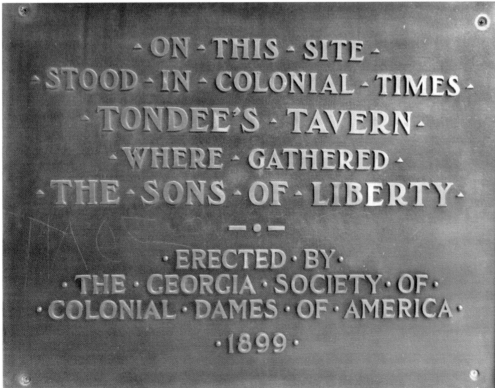

ON THIS SITE STOOD IN COLONIAL TIMES TONDEE'S TAVERN WHERE GATHERED THE SONS OF LIBERTY

ERECTED BY THE GEORGIA SOCIETY OF COLONIAL DAMES OF AMERICA
1899

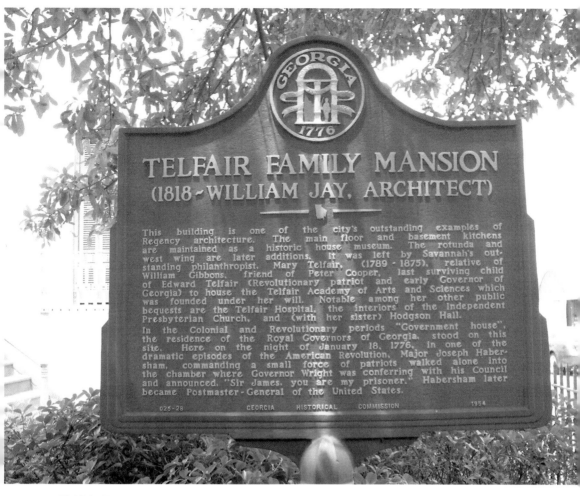

GEORGIA
1776

TELFAIR FAMILY MANSION
(1818~WILLIAM JAY, ARCHITECT)

This building is one of the city's outstanding examples of Regency architecture. The main floor and basement kitchens are maintained as a historic house museum. The rotunda and west wing are later additions. It was left by Savannah's outstanding philanthropist, Mary Telfair, (1789 - 1875), relative of William Gibbons, friend of Peter Cooper, last surviving child of Edward Telfair (Revolutionary patriot and early Governor of Georgia) to house the Telfair Academy of Arts and Sciences which was founded under her will. Notable among her other public bequests are the Telfair Hospital, the interiors of the Independent Presbyterian Church, and (with her sister) Hodgson Hall.
In the Colonial and Revolutionary periods "Government house", the residence of the Royal Governors of Georgia, stood on this site. Here on the night of January 18, 1776, in one of the dramatic episodes of the American Revolution, Major Joseph Habersham, commanding a small force of patriots walked alone into the chamber where Governor Wright was conferring with his Council and announced, "Sir James, you are my prisoner." Habersham later became Postmaster-General of the United States.

025-28 GEORGIA HISTORICAL COMMISSION 1954

Telfair Family

Edward Telfair was the patriarch of the distinguished Telfair family; he was born in Scotland in 1735 and set sail for Virginia when he was in his early 20s. He moved to North Carolina and arrived in Georgia in 1766. He became a planter and a merchant and was successful in business. He married Sarah Gibbons in 1774, and they had six children. Telfair joined the Liberty Boys in their struggle for American independence and was part of the group with Joseph Habersham and Noble W. Jones that stormed the British powder magazine and stole 600 pounds of powder.

Although Telfair was barred from running for public office because of his activities as a member of the rebel Congress, he ran anyway and was elected governor of Georgia in 1786. He ran again and served as governor from 1790 to 1793. As the capital was moved from Savannah to Augusta, the Telfairs greeted George Washington and entertained him at their home in Augusta when he visited Georgia in 1791.

Telfair died at his Savannah townhouse in 1807, and he was buried at his plantation outside of Savannah. Later, his body was moved to Bonaventure Cemetery in 1860, where his daughters created a memorial to honor their father. (Courtesy of the author.)

Mordecai and Frances Hart Sheftall

Mordecai Sheftall was captured by the British during the American Revolution, and his wife held on during difficult times. Sheftall was a Savannah native and the highest-ranking Jewish officer on the American side in the Revolutionary War. He and his son Sheftall Sheftall were taken captive by the British in 1778, when the British regained control of Savannah. Separated from his son, who was only 16 years old, he remained without food on a British ship until a Hessian soldier discovered Sheftall could speak his language. They spent several years as prisoners on the ship until they were returned to Savannah in 1782.

Frances Hart of Philadelphia, Pennsylvania, married Mordecai Sheftall, and they moved to Savannah. She held the family together while her husband and son were imprisoned. Only 16 when he was imprisoned, her son became flag master of an American ship that ran supplies through the British blockade. (Both, courtesy of Marion Abrahams Levy.)

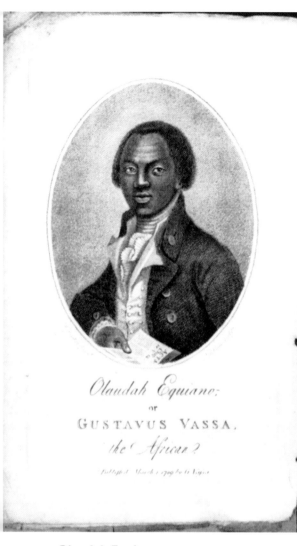

THE

INTERESTING NARRATIVE

OF

THE LIFE

OF

OLAUDAH EQUIANO,

OR

GUSTAVUS VASSA,

THE AFRICAN.

WRITTEN BY HIMSELF.

Behold, God is my falvation; I will truft, and not be afraid, for the Lord Jehovah is my ftrength and my fong; he alfo is become my falvation.
And in that day fhall ye fay, Praife the Lord, call upon his name, declare his doings among the people. Ifa. xii. 2. 4.

EIGHTH EDITION ENLARGED.

NORWICH:

PRINTED FOR, AND SOLD BY THE AUTHOR.

1794.

PRICE FOUR SHILLINGS.

Formerly fold for 7s.

[Entered at Stationers' Hall.]

Olaudah Equiano;

or

GUSTAVUS VASSA.

the African?

Olaudah Equiano

Olaudah Equiano was born in Nigeria about 1745, and he was the son of a tribal chief. At age 11, he and his sister were snatched up and put on a slave ship to be sent to America. For some reason, he was not sold into the plantation system but spent many years as an enslaved river pilot, some of which were spent on the Savannah River. He purchased his freedom in 1766 and traveled widely afterwards. His life is an amazing story, chronicled in *The Interesting Narrative of the Life of Olaudah Equiano*, which he published in London in 1789. (Courtesy of the Library of Congress.)

CHAPTER THREE

Early 19th Century

Savannah was still the center of activity in the state of Georgia in the early 19th century, although its population was expanding to the north and the west. After the Revolutionary War, Georgia's capital had moved to Augusta, Louisville, and Milledgeville as the frontier moved westward. The capital remained at Milledgeville through the Civil War and then moved farther northwest to Atlanta, which grew quickly in population as a result of the railroad.

Although no longer the capital, Savannah became a prosperous city in the early 19th century on the trade of goods exported from the port. Cotton had reemerged as a major crop on the heels of Eli Whitney's invention of the cotton gin, but rice was still the predominant cash crop grown along the coastal waterways. Savannah merchants became wealthy and built some lovely mansions. Of these, the Owens Thomas House, the Telfair Museum, the Scarbrough House, the Green Meldrim House, the Juliette Low Birthplace, the Andrew Low House, and the Davenport House are the most outstanding. However, slavery had become legal, and most of the work on the plantations was accomplished by enslaved hands. The enslaved population in 1800 (8,000) was greater than the white population (5,000), and there were some free blacks earning a living as entrepreneurs.

Savannah was first in many things during this period. James Johnston of Savannah had earlier produced the *Georgia Gazette*, Georgia's first newspaper, in 1763. The SS *Savannah*, the first steamship to cross the Atlantic Ocean, sailed from Savannah in 1819. As the population extended westward, Savannah built a canal to bring the cotton from the plantations to the city for export. The Savannah-Ogeechee Canal connected the Savannah River to the Ogeechee River, an extension of 16 miles. Slaves and Irishmen performed the work, completing the canal in 1831.

Savannah experienced its share of disasters also, including the fires of 1796 and 1820, which destroyed almost half of the city. A major hurricane in 1854 flooded many of the cotton and rice fields and disabled the port. Yellow fever epidemics in 1820 and 1854 took hundreds of Savannah lives. But Savannah continued as Georgia's largest and most prosperous city, and with the city plan extended out to Forsyth Park in 1851, Savannah was also regarded as the most beautiful.

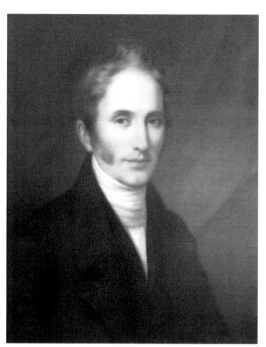

Dr. George Jones

Dr. George Jones studied medicine with his father. Jones was born in 1766, the only son of the 14 children born to his parents, Sarah and Noble Wimberly Jones, to outlive them. He grew up at Lambeth, the family plantation on the Ogeechee River. Following in his father's footsteps, he became a medical doctor. He practiced with his father and was elected president of the Georgia Medical Society three times. (Courtesy of the author.)

House of George Jones

George Jones's house still stands on President Street. He was interested not only in medicine but also politics and public service. In 1796, Jones was elected senator, and he was chosen to be a delegate to the Constitutional Convention of 1798. He was elected a judge of the Chatham County Court in 1804, serving as superior court judge until 1817, and was elected mayor of Savannah in 1812. He died in 1838 and was buried at Bonaventure Cemetery after people paid their respects at his residence on South Broad (Oglethorpe Avenue) and Bull Streets. Earlier he had lived at 509 East President Street. (Courtesy of the author.)

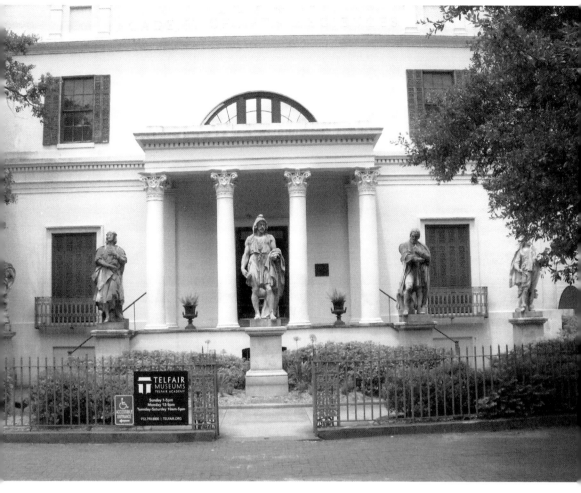

Alexander Telfair

Alexander Telfair built the Telfair mansion.

Alexander Telfair was one of six surviving children of Edward and Sarah Gibbons Telfair. Born in 1789, Alexander had two older brothers and three younger sisters. Alexander and his brothers were sent up north to school and graduated from the College of New Jersey, later Princeton University. His sisters were also educated in the north. When Edward Telfair died in 1807, his sons managed his plantations and financial holdings.

Alexander's brother Thomas was the only brother to marry, and he died soon after at age 31. Following the deaths of both his older brothers, Alexander Telfair decided in 1819 to build a mansion on property he owned on St. James Square, later Telfair Square. He hired architect William Jay to build a home big enough for his mother, himself, and his three sisters. He lived there until he died in 1832. (Courtesy of the author.)

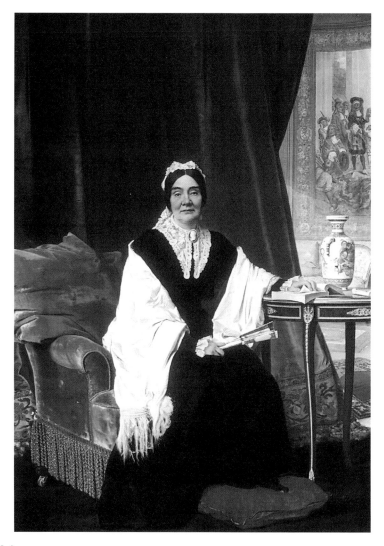

Mary Telfair

Mary Telfair was Savannah's greatest benefactor. She was born in 1791 in Augusta, which was then the capital of Georgia. Her father, Edward Telfair, was serving as governor of the state, and her mother, Sarah Gibbons, was from a wealthy and distinguished family. Mary was educated at the best schools, and her keen intellect accompanied an independent spirit. She loved books and reading poetry. Although women of her day were not encouraged to express political opinions, Mary is said to have argued with Supreme Court justice James Moore Wayne on the merits of renewing the national bank charter. She maintained a friendship with Nicholas Biddle, the president of the Bank of the United States from 1823 to 1836. Although small in stature, she towered over others in conversational skills and in managing her own affairs.

Mary lived in the beautiful Telfair mansion, designed by William Jay and built by her brother Alexander Telfair for her and her mother and sisters in 1819. Mary outlived her other family members and was the last to bear the Telfair name. When she died in 1875, she left her home to the Georgia Historical Society for the purpose of establishing the Telfair Academy of Arts and Sciences, now the Telfair Museum. She also left the money for the Telfair Hospital and an endowment for the Independent Presbyterian Church. (Courtesy of the Telfair Museum of Art.)

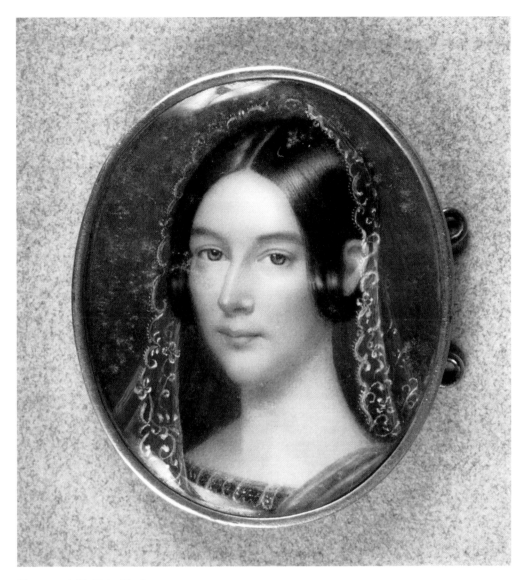

Margaret Telfair Hodgson

Margaret Telfair Hodgson built the Georgia Historical Society Library as a memorial to her husband. She was born in 1797 to Edward and Sarah Gibbons Telfair. Both parents were from distinguished families, and Edward was almost 40 years old when they married in 1774, and Sarah was only 16. Margaret was one of six surviving children in the Telfair family, and they were all well educated and versed in the arts. Margaret met William Brown Hodgson when she was traveling in Europe and he was stationed with the State Department in Paris. They were married in London in 1842, and they returned together to Savannah.

Margaret and William Hodgson lived in the Telfair mansion that Alexander had built for the family with Mary and Sarah Telfair, Margaret's sisters, who never married. When her husband died in 1871, Margaret constructed a new library for the Georgia Historical Society in his memory. The building facing Forsyth Park was named Hodgson Hall, and at the dedication, Carl Brandt's portrait of Hodgson was unveiled. Gen. Henry R. Jackson delivered a stirring tribute to honor of the scholar and diplomat. (Courtesy of the Telfair Museum of Art.)

William Brown Hodgson

William Brown Hodgson was a scholar and a diplomat who spoke 13 languages. Born in Washington, DC, in 1801, Hodgson was left fatherless as a little boy. He did not attend college but was tutored by Rev. James Carnahan, the future president of the College of New Jersey, later Princeton University. While in Georgetown, Hodgson developed a friendship with local lawyer Francis Scott Key. Congressman Henry Clay noticed that Hodgson had a natural affinity for languages, and he sent him to North Africa to learn Berber. Hodgson served with the US State Department and traveled to Egypt, Turkey, Tunisia, Peru, and other countries. While stationed in Paris he met Margaret Telfair, who became his wife in 1842.

Hodgson's scholarly pursuits led him to become a curator at the Georgia Historical Society and write a paper on the geology of the Georgia coast. Hodgson based most of his ethnological and linguistic scholarship on his contacts with the slaves on the Telfair plantations. He noticed the ethnic diversity among the populations, and he could distinguish among the Mandingo, Ebo, Gullah, Fula, and the people from Guinea. As a result of his study of languages, he was able to converse with them in their native tongues. (Courtesy of the Telfair Museum of Art.)

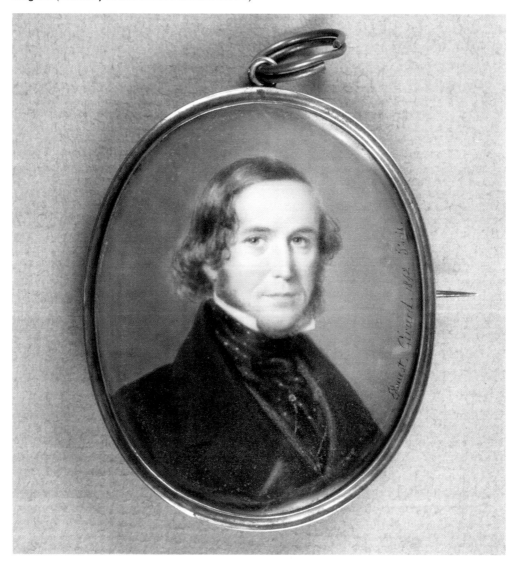

John MacPherson Berrien and His Home

John MacPherson Berrien was a US senator and served as attorney general of the United States under Pres. Andrew Jackson. Berrien was born at Rocky Hill, New Jersey, near Princeton, in 1781, at the home of his grandfather John Berrien. His grandfather was of French Huguenot ancestry and a friend of George Washington. Berrien's father, John Berrien, served in the Revolutionary War under Gen. Lachlan McIntosh of Georgia.

John M. Berrien moved with his parents to Savannah in 1782, and he graduated from the College of New Jersey, later Princeton University, with a bachelor of arts degree at the age of 15 in 1796. He studied law in Savannah in the office of Joseph Clay, a prominent lawyer and federal judge, and was admitted to the bar at 18.

Berrien was elected to the Senate by the State of Georgia in 1825, and he proved himself an eloquent speaker and debater. His expertise earned him the nickname "American Cicero," and Chief Justice John Marshall called him "the honey-tongued Georgia youth."

John Berrien's home on Broughton Street is being restored. His father built the house in 1791, and the house welcomed many distinguished visitors while the Berriens lived there. The younger John Berrien lived there with his family from 1824 until his death in 1856. (Left, courtesy of V&J Duncan Antique Maps, Prints & Books; right, courtesy of the author.)

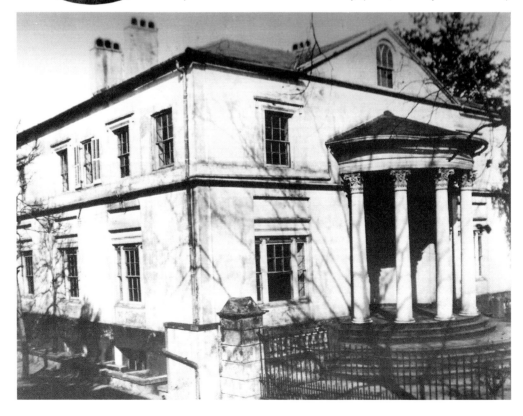

Robert Habersham and the Bulloch Habersham House

Robert Habersham was head of the export firm Habersham and Harris, and he needed all the space provided by the historic Bulloch Habersham House. Habersham was born in 1783 to Col. Joseph Habersham and his wife, Isabella Rae. He became head of the family cotton business, founded in 1744 by his grandfather James Habersham. Habersham was married to Mary O'Brien and had two children, Mary and Robert. After his first wife's death, he married Elizabeth Neyle and had two more children, Isabella and William Neyle Habersham. After Elizabeth's death he married Mary Butler Habersham, his third wife and first cousin, and had five more children.

In 1819, Habersham bought the beautiful home on Orleans Square designed by William Jay for Archibald Bulloch. He lived there with his family and the three orphaned children of his brother William Habersham, whom he adopted. When his brother Joseph Habersham Jr. died in 1831, he took in Joseph's three children and their mother, Susan Habersham, sister of his third wife, Mary. It was fortunate that Habersham was successful in business as well as family life. His son William Neyle Habersham maintained R. Habersham and Company as a successful export business into the next century. (Both, courtesy of the author.)

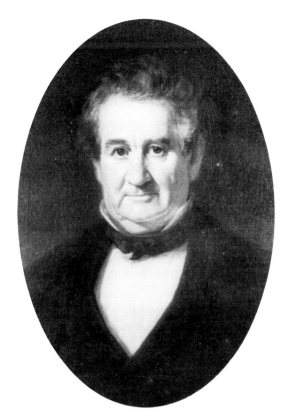

Dr. Joseph Clay Habersham

Dr. Joseph Clay Habersham was born in Savannah in 1790 to John and Ann Sarah Camber Habersham. His father, John Habersham, was a distinguished Patriot who fought in the Revolutionary War with his two brothers, James and Joseph. His grandfather James Habersham was one of the founding fathers of Georgia, shipping the first cotton out of the port of Savannah.

Joseph Habersham was educated at Princeton and began the study of medicine in 1810 in Savannah. He was a surgeon with the Army during the War of 1812 and returned to Savannah to practice medicine.

He was the health officer of Savannah for many years and president of the Medical Society of Georgia. He was noted for his benevolence and love of science, especially botany, zoology, and geology. He loved music and played the violin. Each of his children played a musical instrument.

As an amateur geologist, he contributed a chapter in William B. Hodgson's *Memoir of a Megatherium* in 1846. He lived at White Bluff and married Ann Wylly Adams, who also grew up at White Bluff on the Vernon River. His daughter Josephine Habersham married her second cousin William Neyle Habersham, and they bought a place nearby on the Vernon River. Piano and flute duets could be heard down the bluff, and it is said that the slaves all whistled Mozart.

Dr. Habersham was told by an old African American man about a good fishing drop on the Vernon River where an old stump protruded out of the ground and it was easy to tie up an old bateau. Dr. Habersham expressed an interest, and the old man rowed him out to the site. Upon examining the stump, Dr. Habersham recognized it to be the femur of a mastodon, an extinct animal related to the elephant that grazed the coastal plains 10,000 years ago.

Dr. Habersham and the fisherman together excavated the almost-complete skeleton. On each bone, Dr. Habersham carefully carved his initials, JCH. One night, the Habershams were entertaining a young French lieutenant who was very interested in the bones. He asked Dr. Habersham if he could take them to Paris to be examined, and Dr. Habersham would be made a Fellow of the Royal Academy. Dr. Habersham agreed; the man sailed away to France and was never heard from again. (Courtesy of the author.)

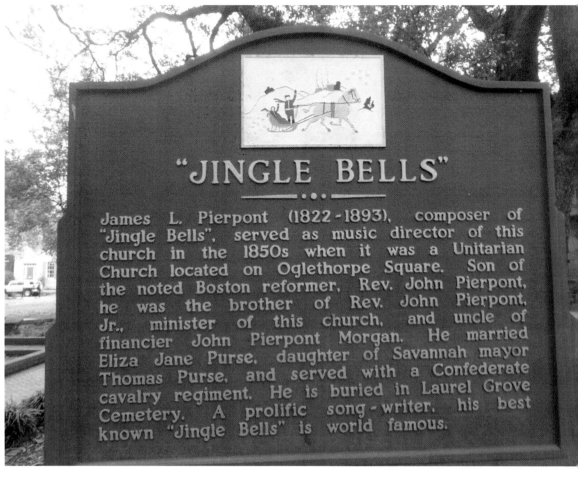

James L. Pierpont

James Pierpont wrote the famous Christmas song "Jingle Bells" while he was serving as organist and music director at the Unitarian Universalist church in 1857. At least, that is what people in Savannah believe. He also wrote the song while serving as music director at a church in Medford, Massachusetts, in 1850. Wherever he was, he certainly must have had Massachusetts in mind when he wrote about a one-horse open sleigh, as he would never have encountered one of those in Savannah. He was the brother of Rev. John Pierpont Jr., rector of the Unitarian church in Savannah, and uncle of financier James Pierpont Morgan. He married Eliza Jane Purse, the daughter of Savannah mayor Thomas Purse, and they are buried in Laurel Grove Cemetery. (Courtesy of the author.)

CHAPTER FOUR

Civil War

Savannah's progress was built on the thriving plantation economy, cotton in most of Georgia and rice along the coast. The families that owned the plantations nearby often lived in the city, leaving the daily work to the slaves and a manager who lived at the site. During this time, two different cultures arose among the white privileged class and the slaves who held on to their customs and traditions as well as they could.

When Abraham Lincoln was elected president of the United States in 1860, Southerners knew that they were threatened with losing their way of life. They felt that people in the North did not understand plantation life, and it would be necessary to take the drastic step of seceding from the United States rather than be told what to do. Even before South Carolina fired on Fort Sumter, Savannah took the step of seizing the Federal Fort Pulaski just outside of the city. Gen. Alexander Lawton and the Georgia Militia marched down the Tybee Road and took over the fort in January 1861. The shots that began the Civil War were fired at Fort Sumter in April that same year.

The Federal troops took Fort Pulaski back in April 1862 by firing rifled cannon from Tybee Island. The fort was considered impregnable until this new technology was demonstrated. The Yankees held the fort and blockaded the river until the end of the war, inflicting hardship and great inconvenience on the people of Savannah.

In December 1864, when General Sherman ended his March to the Sea in Savannah, the war was almost over. The people in Savannah were thankful that Sherman did not burn the city as he had Atlanta, and he continued on to Columbia, South Carolina.

In many ways, the African American Civil War story differs from the white story, yet they have much in common. Most slaves left when they had the chance to escape to freedom. In some families, the slaves felt so much a part of the family that they remained. One story tells about a young woman who escaped to join the Union army, serving throughout the war as a nurse. Another story tells of a young man who stayed with his young master in the Confederate army so that he could return the body to the parents. It was a time of tragedy and a time of heroism and loyalty in Savannah and all across the South.

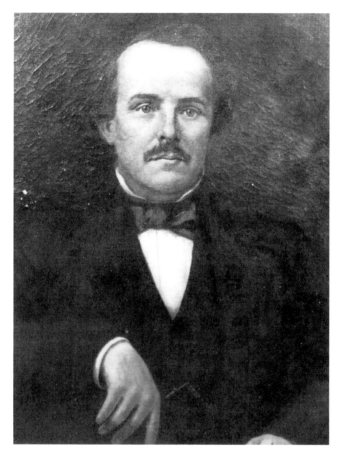

Francis Bartow

Francis Bartow was born in Savannah in 1816 and became a Civil War hero, the first Savannah soldier killed. In college he was mentored by John M. Berrien, a US senator and former attorney general in Pres. Andrew Jackson's administration. He graduated cum laude at age 19 from Franklin College in Athens, which later became the University of Georgia. He studied law at Yale Law School and returned to Savannah in 1837.

Bartow served two terms in the Georgia House of Representatives and one in the Georgia Senate. In 1844, he married Louisa Greene Berrien, the daughter of his mentor, Sen. John Berrien. In 1857, he was elected captain of Savannah's 21st Oglethorpe Light Infantry. He served as instructor to the volunteers, many of whom were the sons of Savannah's prominent families. Bartow was an ardent secessionist, and it was his military unit under Gen. Alexander Lawton that marched to Fort Pulaski to seize the fort from the Federal troops in 1861. Bartow was an advocate for fast, drastic action against the North. He helped select the color and style of the initial Confederate uniforms, and he took the Oglethorpe Light Infantry directly up to Jefferson Davis in Virginia against Governor Brown's orders.

Bartow and his troops fought bravely with Gen. P.G.T. Beauregard at the Battle of Manassas, where Bartow was fatally wounded. As he lay on the battlefield with his soldiers surrounding him, he said, "They have killed me, boys, but never give up the fight." He was the first brigade commander to be killed in action in the Civil War. "You Georgians saved me," is what General Beauregard said of him.

Bartow's body was returned to Savannah, and he is buried at Laurel Grove. A memorial and bust of Francis Bartow and one of Lafayette McLaws were placed in Chippewa Square and later moved to Forsyth Park. They stand just north and south of the Confederate monument in Forsyth Park. (Courtesy of V&J Duncan Antique Maps, Prints & Books.)

Alexander Lawton

Alexander Lawton was a prominent Confederate general, born across the river in Beaufort, South Carolina, in 1818, but he came to Savannah to practice law after graduating from West Point Military Academy and Harvard Law School in 1842. He favored Georgia's secession and became colonel of the 1st Georgia Volunteers. He commanded the Savannah troops that seized Fort Pulaski from the Federal troops in 1861.

Lawton was made a brigadier general in charge of coastal defenses. He was sent to Virginia and fought with Stonewall Jackson in the Shenandoah Valley; he fought with the Army of Northern Virginia and was seriously wounded at the Battle of Antietam. After his recovery, he was made quartermaster general of the entire Confederate army. After the war, he was elected president of the Georgia Bar Association and later appointed minister to Austria.

In 1897, the Lawton family constructed a handsome public building on Bull and Anderson Streets to be used for cultural and educational purposes in memory of General Lawton and his daughter Corinne. The building was a gift to the City of Savannah, which later sold it to the Greek Orthodox Church. The monument where he is buried in Bonaventure Cemetery stands beside the Wilmington River, one of the most photographed sites in the city. (Courtesy of Spencer Lawton Jr.)

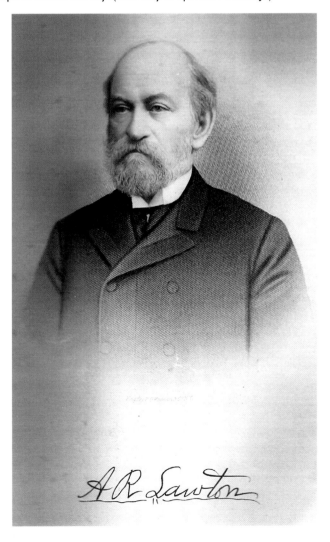

Edward Clifford Anderson

Edward Clifford Anderson was elected mayor of Savannah in the first elections held after the Civil War. Anderson was born in Savannah in 1815 to George Anderson and his wife, Eliza Clifford Wayne. He attended Round Hill School in Northampton, Massachusetts, as was the custom for many wealthy Savannah families. He served as a US Navy officer from 1835 to 1839 and from 1842 to 1846, traveling to the Mediterranean Sea and along the eastern Atlantic coast. All of his notes and diaries are in a collection at the Georgia Historical Society.

Edward Anderson served as a Confederate army officer and was elected mayor of Savannah; he served six terms as mayor between 1865 and 1877. He was president of the Ocean Steamship Company and was on the governing boards of the Georgia Historical Society, the Independent Presbyterian Church, Massie School, and many other organizations. He died in Savannah in 1883 at age 68 and is buried at Laurel Grove Cemetery. (Courtesy of the City of Savannah, Research Library and Municipal Archives.)

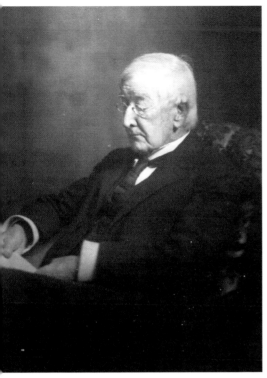

William Neyle Habersham

William Neyle Habersham continued the family cotton business of R. Habersham and Sons, which shipped the first cotton from Georgia. Habersham married his second cousin Josephine Clay Habersham in 1840 at Christ Church in Savannah. Josephine's name was Habersham before she married, and they shared a great-grandfather, James Habersham, who was one of the founding fathers of Georgia. In 1854, they bought an old house on the Vernon River at White Bluff that had previously been a boys' school. The White Bluff house was a summer home, and in the winters they lived in a house on the corner of Barnard and Harris Streets in Savannah.

Habersham graduated from Harvard College at age 19, and he returned to Savannah to work as a rice merchant on the Savannah River. He joined his father's cotton business, Habersham and Harris, the company founded by his great-grandfather in 1744. The company was located on Bay Street on the Savannah River and shipped the first bale of cotton from Georgia. (Both, courtesy of the author.)

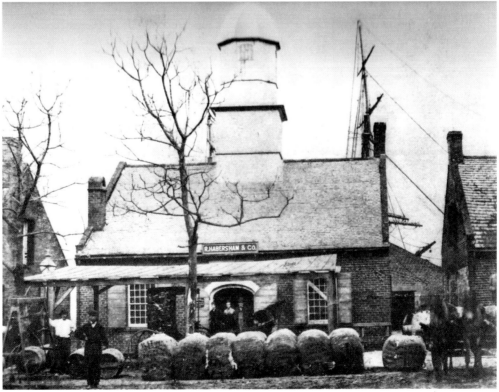

EBB
TIDE

As Seen Through the Diary of
Josephine Clay Habersham
1863

By SPENCER BIDWELL KING, JR.

Josephine Habersham

Josephine Habersham was an author and lover of music, and her Civil War diary was later published as *Ebb Tide*. She was an accomplished pianist and enjoyed accompanying her husband, who played very well on the flute. The house was filled with music, but Josephine's other love was literature; she named the White Bluff house Avon Hall because of her love of Shakespeare.

Earlier, Henry W. Longfellow, a professor at Harvard, wrote of Neyle Habersham, "He was a skillful performer on the flute. Like other piping birds he took wing for the rice-fields of the South when the cold weather came."

Josephine's mother, Ann Wylly Adams Habersham, lived less than a mile up the river from Avon Hall. One summer evening when the family was having dinner on the porch, Ann noticed the pleasant evening breeze and suggested that although the breeze was nice, it could not compare with the breeze she felt at the Adams home up the river. "The breeze is so strong at my house it blows the silver right off the table," she commented. Neyle Habersham answered right back. "But, Mother Ann, that's because the Adams silver is so much lighter than the Habersham silver." (Both, courtesy of the author.)

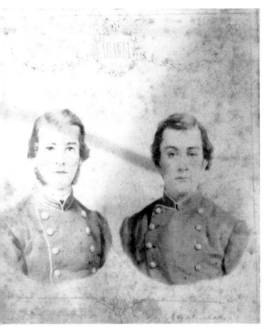

The Habersham Brothers
The Habersham brothers were killed on the same day in the Battle of Atlanta. Joseph Clay "Joe Clay" Habersham and his younger brother William Neyle "Willie" Habersham were excited to join the Confederate army to fight against the Yankees. They believed they were defending their country's honor, and they were devoted to the cause.

On the evening of July 21, 1864, Joe Clay wrote home to his mother in Savannah, "Willie and I are well." "My love and Willie's to all at home," he remarked, including greetings to his brothers and sisters as well as the servants by name: Norah, Dinah, Fredericka, and Tom.

Joe Clay and Willie were both killed in the Battle of Atlanta on July 22. The boys are buried together at Laurel Grove in Savannah, and the inscription on the white marble obelisk reads, "In their death they were not divided." (Courtesy of the author.)

Dinah Bush
Dinah Bush was a servant of the Habersham family. Not much is known about the servants Joe Clay Habersham mentions in his letter, but what is known is the affection and loyalty he felt for them. It is not known if they were slaves or free. The image of Dinah Bush in the Habersham family album shows a woman in her later years, nicely dressed, reflecting both elegance and determination. The children all called her "Dah." (Courtesy of Lisa Raffetto.)

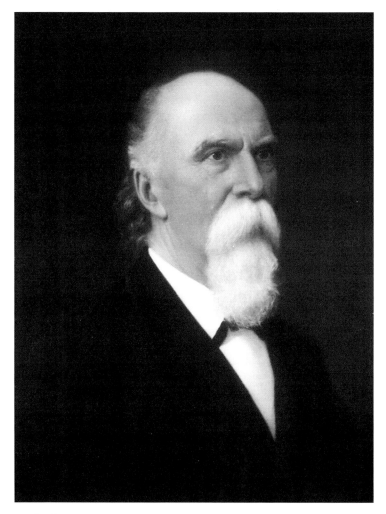

Henry Rootes Jackson

Henry Rootes Jackson was a lawyer, Confederate general, and poet. Born in Athens, Georgia, in 1820, Henry R. Jackson was tutored by his father, a professor at the University of Georgia. He graduated with honors from Yale University in 1839 and returned to Georgia to study law. He practiced law in Savannah and was appointed a US district attorney at age 23.

In 1843, he married Cornelia Davenport, and they had four children before she died in 1853. Jackson was a frequent public speaker and wrote poetry as well. He gave a speech on courage to the University of Georgia literary societies in 1848 and spoke at the dedication of the new Laurel Grove Cemetery in 1852. His book of poetry *Tallulah and Other Poems* appeared in 1850.

Jackson was a judge of the Eastern Circuit of Georgia from 1849 to 1853, and in 1859, he was a special prosecutor for the United States in the case of the slave ship *Wanderer*. Jackson felt it was hypocritical for Northerners to make money bringing ships filled with illegal cargo to Savannah docks and then criticize the South for slavery.

Jackson enlisted in the Confederate army in 1861 and led a brigade during the defense of Atlanta against Sherman in 1863. He was captured later in the Battle of Nashville and imprisoned in Massachusetts. After the Civil War, he was released and returned to Savannah to resume his law practice. He was a railroad executive, banker, and president of the Georgia Historical Society from 1875 to 1898. He died at his home on Gaston Street, where the Oglethorpe Club is today. (Courtesy of the Telfair Museum of Art.)

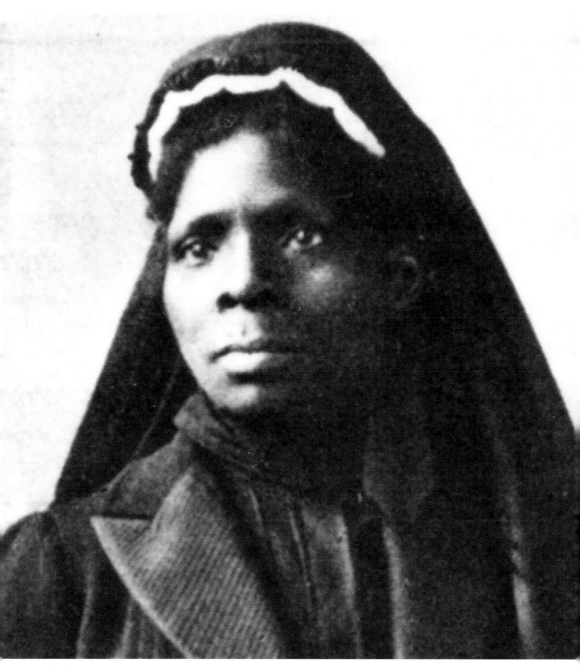

Susie King Taylor
Susie King Taylor learned to read and write and kept a memoir during the Civil War. Taylor was born into slavery in Liberty County, Georgia, in 1848. Most enslaved Americans had no genealogical records for their families, but Taylor had the benefit of oral history passed down through generations. Additionally, Susie learned to read and write in an underground school in Savannah, and she kept a diary that tells an amazing story of her life during the Civil War. (Courtesy of the Library of Congress.)

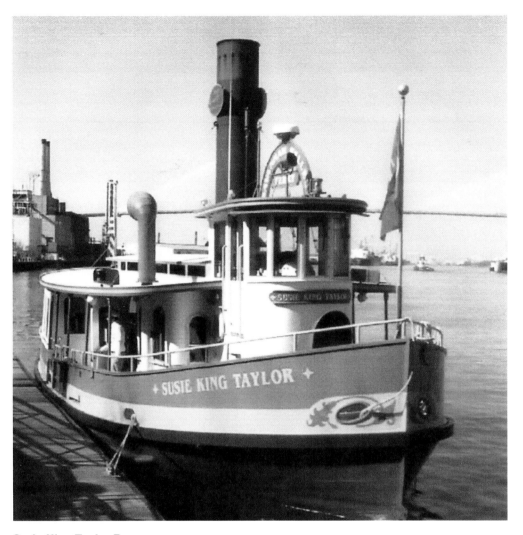

Susie King Taylor **Ferry**
The ferry taking visitors across the Savannah River is named for an African American woman. After the war, Taylor was sent to Charleston, where she joined the Army. She married Edward King, who had escaped from his master and joined the Army. She met Clara Barton in Beaufort and learned nursing skills from her. After Edward King died, Susie went to Boston as a gourmet cook and married Russell Taylor. In Savannah, she is remembered by all those interested in black and women's history and honored with a little ferryboat that bears her name that transports visitors across the river. (Courtesy of the author.)

Bishop Stephen Elliott

Bishop Stephen Elliott was the first Episcopal bishop of Georgia. In 1840, the convention of the Georgia diocese met to elect its first bishop in a little church in Clarkesville, Georgia, that still stands today. Bishop Elliott was rector of St. John's Church in Savannah and gave the whole community emotional support during the tragic years of war. (Courtesy of Christ Church Episcopal.)

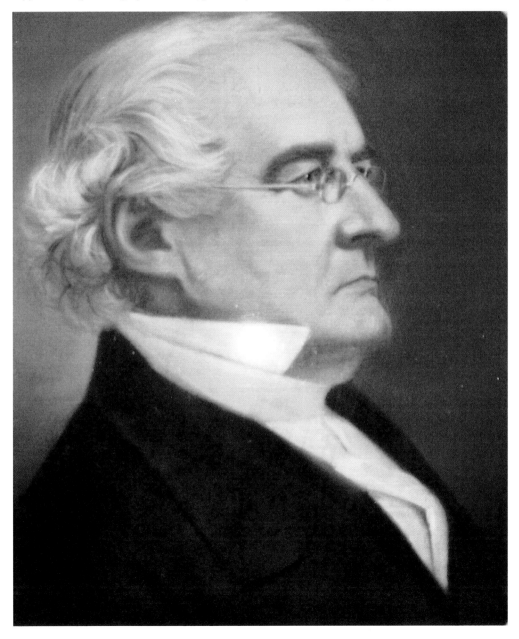

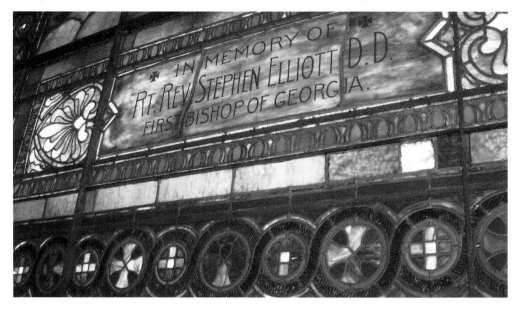

Ascension Window at Christ Church.
Bishop Stephen Elliott was consecrated at Christ Church on February 28, 1841, and the Ascension Window in the church is given in his memory. He was instrumental in founding the University of the South in Sewanee, Tennessee, and he started a school for girls in Montpelier, Georgia. Rebecca Mathews Meriwether, a 16-year-old student at Montpelier, wrote to her uncle on April 25, 1843. "I am studying history, geography, philosophy, logic, rhetoric, mathematics, French, Italian, and I commit a great deal of poetry to memory"—a big step up from needlepoint. (Courtesy of Ted Eldridge.)

St. Stephen's Episcopal Church
Bishop Elliott established the first black Episcopal church in Georgia, and St. Stephen's was named after him. Later, St. Stephen's merged with another black Episcopal congregation to form St. Matthew's, an active parish on the west side of town. (Courtesy of Stephen Lain.)

CHAPTER FIVE

Late 19th Century

A period of reconstruction took place following the Civil War, even though Savannah was not one of the cities destroyed in the conflict. Many of the wealthy plantation owners were able to have at least some of their property restored to them by signing an oath of loyalty to the United States. Savannah had an influx of African Americans, but there were not enough jobs or satisfactory places for them to live. General Sherman had promised 40 acres and a mule to black families, but the promises were not realized. It was a difficult time for many people.

By 1870, African Americans were given the right to vote and run for public office. Previously, each black person had been considered three-fifths of an individual for census purposes, which meant that suddenly the population of Savannah was greatly increased. Many blacks as well as rural whites were illiterate, as there were not yet any public schools, and some people questioned whether they should be allowed to vote. There was also the question of whether former Confederate supporters would be allowed to vote.

The Freedmen's Bureau was established in Washington, DC, to help freed African Americans in Savannah and other cities. They sent people down to distribute food, clothing, and health care to newly freed slaves and encouraged plantation owners to rebuild and create jobs. They established schools in Savannah, teaching African American children to read and write. The program became unpopular in the North and was discontinued within a few years.

By 1866, missionary societies worked in conjunction with the Freedmen's Bureau to provide education for former slaves. Teachers came down from the North, but it was not until 1878 that a public school for blacks was established. In 1890, Georgia's first college for blacks was established, Georgia State Industrial College for Colored Youth, now called Savannah State University.

Many of the good attempts toward equality during Reconstruction were thwarted, and although a few blacks were elected to public office, their terms were short lived. Education was provided for black children—but in segregated schools. It was not until late in the next century that African American civil rights would be realized.

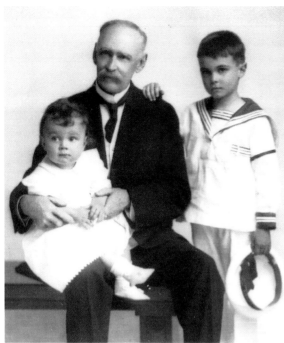

Judge Peter Meldrim
Judge Meldrim was a superior court judge born in Savannah in 1848. He was a distinguished lawyer, scholar, orator, and judge. He served as mayor of Savannah in 1897 and president of the Georgia State Bar in 1904. He is remembered for his three lively and attractive daughters and is pictured here with his grandsons Ralph and Noble Jones. (Courtesy of Anna Habersham Wright.)

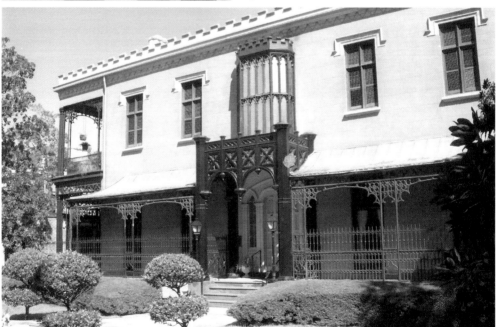

Green-Meldrim House
In 1892, Judge Meldrim bought the beautiful Green-Meldrim home on Madison Square to raise his family. The house was built in 1850 for Charles Green, and it served as General Sherman's headquarters during the Civil War. Peter Meldrim himself had served in the Army at age 16 and attempted to defend Savannah against Sherman's March to the Sea. Today the home is the parish house of St. John's Episcopal Church. (Courtesy of the author.)

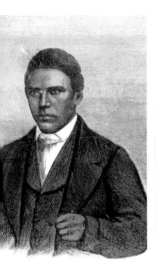

M TURNER, CHAPLAIN FIRST UNITED STATES COLORED REGIMENT.

Bishop Henry McNeal Turner

Bishop Henry McNeal Turner established churches all over Georgia, and he worked at the US Custom House, the first black man to hold that position. The Queen of England acknowledged his work with a bell that still hangs in a local church.

Bishop Turner was inspired by the Methodist Church and ordained a bishop in 1880. In 1863, he had organized the 1st Regiment of US Colored Troops and served as its chaplain during the Civil War. As bishop, he traveled all over Georgia establishing African Methodist Episcopal (AME) churches. In 1885, he became the first AME bishop to ordain a woman, Sarah Anne Hughes, as a deacon.

When he worked at the custom house on Bay Street, he became interested in politics and helped organize Georgia's Republican Party. He was a representative to the state's constitutional convention and was elected to the Georgia House of Representatives.

The most extraordinary memorial to Bishop Turner is the bell in the belfry at St. John AME Church on East Broad Street, which was given to him by Queen Victoria in appreciation for all the churches he started in this country and in British colonies. (Above left, courtesy of the Library of Congress; above right and below, courtesy of the author.)

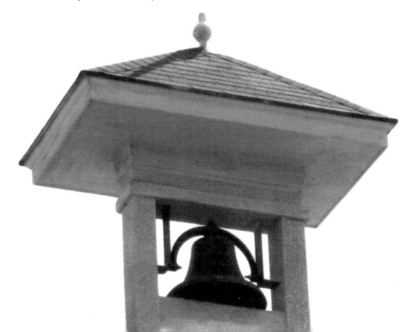

Garrison Frazier, Ulysses Houston, and William Campbell
Garrison Frazier, Ulysses L. Houston, and William Campbell were three black men who met with General Sherman and Secretary of War Edwin Stanton on January 12, 1865, at the Green-Meldrim House, Sherman's Savannah headquarters. The meeting resulted in Sherman's issue of Special Field Order No. 15, which was supposed to give every freed slave 40 acres and a mule. After President Lincoln's death, the order was rescinded, and Savannah's black community was not able to receive any real benefit from it. (Courtesy of V&J Duncan Antique Maps, Prints & Books.)

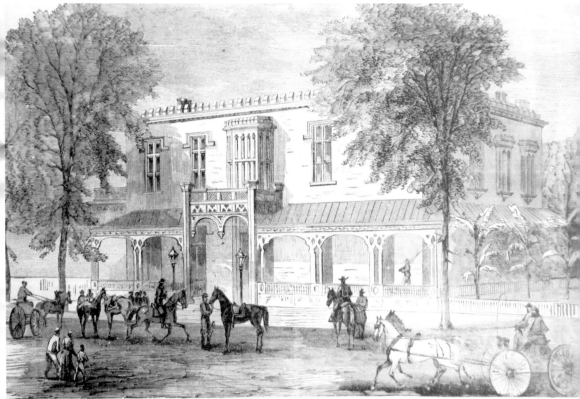

SHERMAN'S HEADQUARTERS AT SAVANNAH.

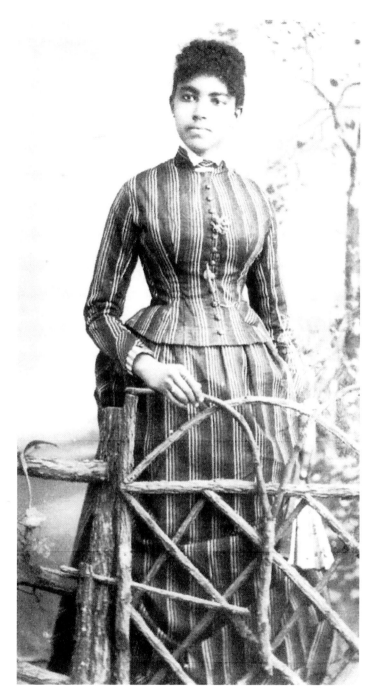

Mother Matilda Beasley

Mother Matilda Beasley was Georgia's first African American nun. Born Mathilda Taylor in 1832, she was the daughter of a slave in Louisiana. She came to Savannah and married Abraham Beasley in 1869. Matilda became active in the Catholic church and traveled to England to train to become a nun. When she returned to Savannah, she established the first order of black nuns and started the St. Francis Home for Orphans for African American girls. (Courtesy of the author.)

MOTHER MATILDA BEASLEY PARK

CHATHAM COUNTY COMMISSIONERS
DEPARTMENT OF PARKS AND RECREATION

PARK AND TRAIL RULES

1. OPEN DAYLIGHT HOURS ONLY
2. SPEED LIMIT 10 MPH
3. BIKES STAY RIGHT
 PEDESTRIANS STAY LEFT
4. STAY ON TRAIL
5. NO VEHICULAR TRAFFIC
6. OBEY TRAFFIC SIGNALS

Mother Matilda Beasley Park
Matilda Beasley operated the orphanage until her death in 1903 at the age of 71. She was found in her private chapel with her hands clasped and her burial garments and will beside her. The park on East Broad Street in Savannah next to East Broad Elementary School has been named for her. The little house she lived in at 1511 Price Street has been moved to the park as an interpretive center. (Courtesy of the author.)

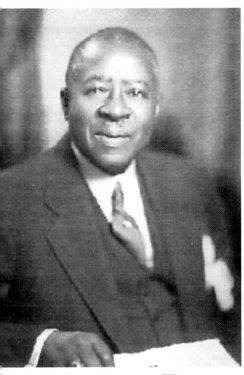

Robert Sengstacke Abbott

Robert Sengstacke Abbott's mother was born a slave, and his stepfather was the son of a wealthy German immigrant. His German immigrant grandfather saw a beautiful slave woman and purchased her from the auction block, marrying her in 1847. Their son John was sent to Germany to be educated, returned to Savannah, and married a widow, Flora Abbott, who had a baby, Robert Abbott, whom John and Flora raised together. Abbott took his stepfather's name for his middle name.

Abbott left Savannah for Chicago, Illinois, where he founded the *Chicago Defender*, a weekly newspaper that spoke out against lynching, racism, and segregation. Numerous well-respected black writers wrote for the *Defender,* including Gwendolyn Brooks and Langston Hughes. After 15 years, the newspaper became the first black publication to reach a circulation of 100,000, and Abbott became a millionaire. The community Abbott built grew in power and influence, eventually helping to propel young Barack Obama into his position as a US senator and president of the United States. (Both, courtesy of the author.)

THE MOUTHPIECE OF
14 MILLION PEOPLE
arries More Live News of Racial Interest Than Any Ten Weeklies

THE
Chicago Defender

wenty Pages of Reading Matter Compiled by Experts

John Deveaux

John Deveaux was born in Savannah in 1848 to a free black family. His parents were Rosa and Isaac Deveaux, and his grandfather was John B. Deveaux, pastor for a short time at First African Baptist Church. John was 13 years old when Georgia seceded from the Union in 1861. He was conscripted to serve the Confederate cause, and he served in the Confederate "mosquito fleet," whose job it was to harass the Federal forces in the harbor. John Deveaux worked as a mess boy for Lt. J.E. Pelot.

One night in 1864, Deveaux was with Lieutenant Pelot, who set out to capture the *Water Witch*, a Federal gunboat anchored in Green Island Sound. As they were about to board the *Water Witch*, Pelot ordered Deveaux to get out of the boat while Pelot and the black pilot Moses Dallas boarded the *Water Witch*. Both men were killed, although the Confederates succeeded in capturing the boat. Deveaux secured the body of Lieutenant Pelot and delivered it to his family.

In 1870, at the age of 22, Deveaux received an appointment as a clerk in the customs house of Savannah. He worked in customs for many years, including keeping the office open during the yellow fever epidemic of 1876.

In 1875, Deveaux started the first black newspaper in Georgia, the *Colored Tribune*, of which he was editor. The newspaper's stated purpose was to defend "the rights of the colored people and their elevation to the highest plane of citizenship." The next year, the name was changed to the *Savannah Tribune*.

The newspaper closed in 1878, as the only printers in town were white printers who refused to print the newspaper. Deveaux reopened the paper in 1886 and served as editor until 1889. Sol Johnson took over as editor and bought the newspaper at Deveaux's death in 1909. (Courtesy of the author.)

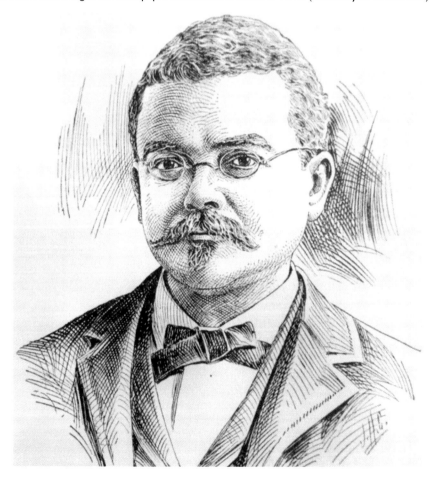

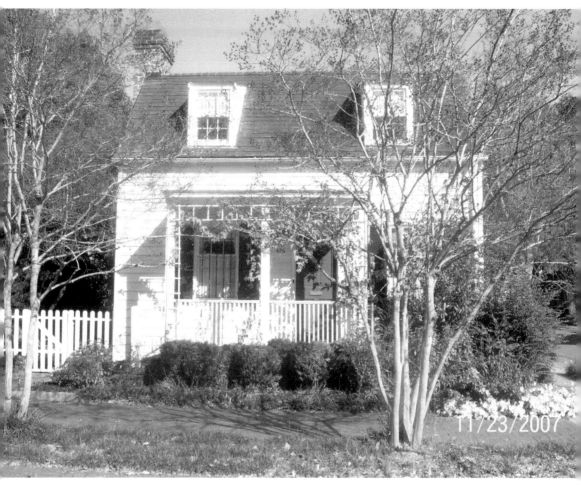

Jane Deveaux

Jane Deveaux was born in 1810, and she and her mother, Catherine, lived in a little house she owned at 426 East St. Julian Street. Catherine was a free woman of color who had come to Savannah from Antigua. She was successful as a seamstress, and she owned a number of properties in the Greene Square area. Catherine's husband was a leader in the Second African Baptist Church, and she owned additional property around Columbia Square and Warren Square.

Between 1818 and 1860, there were at least six schools for black children in Savannah. It was illegal to teach African Americans to read or write, so everything was done in secret. Catherine and her daughter Jane opened a school in their home on St. Julian Street, and Jane was able to keep her school going for 30 years without being forced to close her doors. (Courtesy of the author.)

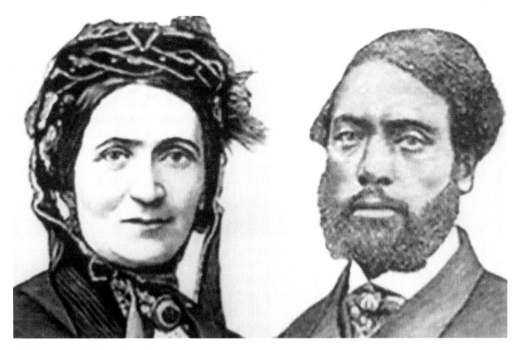

William and Ellen Craft

Ellen Craft was born into slavery in Clinton, Georgia, in 1826. Her mother was a mixed-race slave, and her father was the plantation owner, Maj. James Smith. Ellen was very light skinned and resembled her white half-sisters. Mrs. Smith did not like having Ellen around, so at age 11, she was given to the Smiths' daughter and son-in-law in Macon.

Ellen fell in love with a dark-skinned slave on the plantation named William Craft, and together they planned to run away to freedom. Ellen was a seamstress and William a carpenter, so together they were able to save some money for an extremely daring adventure.

Neither Ellen nor William had been taught to read or write, but they were able to come up with an elaborate plan of escape. Ellen dressed herself as a man, in a suit and top hat, and wore her right arm in a sling, so she would not be expected to write. He dressed as a white man's servant, and they traveled together. They escaped to Savannah and were able to board a ship to Philadelphia. Their adventures and narrow escapes are chronicled in *Running a Thousand Miles for Freedom*, published in 1860.

Ellen and William continued on to Boston, where they were invited by abolitionists to tell their story. They posed in their escape clothes for a lithograph, which was widely distributed as part of the campaign against slavery. They were married there and remained until the Fugitive Slave Act threatened their tranquility in 1850. The Crafts moved to England, where they raised their five children.

After the Civil War, the Crafts returned to the United States with three of their children. They bought a large tract of land outside of Savannah and founded the Woodville Cooperative Farm School in 1873. There they educated young African Americans and prepared them for employment. In 1890, they moved to Charleston to live with their daughter Ellen, who was married to the collector of the port. Their book lives on to provide a look at race, gender, and class in the 19th century. (Courtesy of Dr. Walter Evans.)

George Wymberley Jones DeRenne

George Frederick Tilghman Jones was born in 1827 to Dr. George Jones and his wife, Eliza Smith, from Philadelphia. Later he added the surname DeRenne, changing his name to George Wymberley Jones DeRenne, changing the spelling to Wymberley from Wimberly. He also changed the spelling of the plantation "Wormslow" to "Wormsloe." His father encouraged him to read and study history, and he developed a great love of books. (Courtesy of the author.)

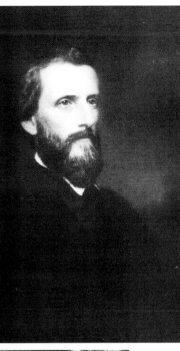

Wormsloe Plantation

G.W.J. DeRenne was the fourth generation to live at Wormsloe. DeRenne always loved the family plantation, and he spent time in the new house his father had built about the time he was born. He grew to appreciate the land that had belonged to his father, grandfather, and the original Noble Jones, his great-grandfather.

Life during the Civil War was difficult, and DeRenne sent his wife and children to Augusta for safety. Mary was pregnant with their fourth child, Kentwyn, who was born there. She also spent some time at Oaklands, George Noble Jones's plantation near Louisville, Georgia, and at Flat Rock, North Carolina. DeRenne stayed behind to run Wormsloe and contribute food to the war effort. His health was not good, but he was able to contribute to the war financially. (Courtesy of the author.)

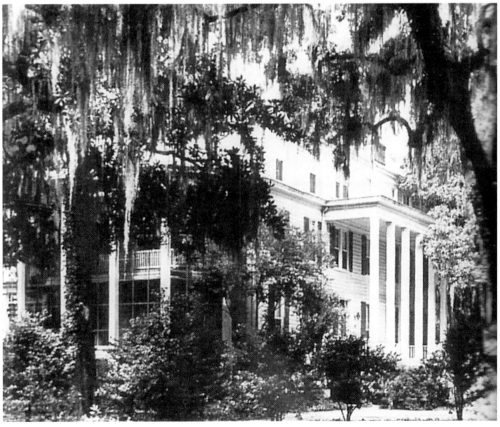

Scarbrough House

After the war, DeRenne made many civic contributions, including buying the beautiful Scarbrough House, designed by William Jay for use as a school for black children. He also presented the bronze statue of a Confederate soldier to be placed on the pedestal of the Confederate monument in Forsyth Park.

G.W.J. DeRenne died in 1880 and was buried in Bonaventure Cemetery. His widow, Mary, continued his philanthropic work by giving a school for black children on the east side of the city. She also contributed funds to build a wing at Bethesda Orphan School. Their oldest son, Wymberley, married and continued the tradition of book collecting and family life at Wormsloe. (Courtesy of the author.)

CHAPTER SIX

Early 20th Century

By the turn of the 20th century, Savannah was a busy place, with cotton and naval stores as the main exports from the port. Union Camp Paper Corporation built a big plant and was the city's biggest employer. Pine trees were essential to the paper industry as well as for turpentine, and they grew fast and plentifully in Georgia. Cotton flourished until the boll weevil appeared in 1920 and dealt a blow to the economy. The city grew, and the port expanded to become one of the busiest on the East Coast.

Savannah women began to strike out on their own, one founding the Girl Scouts of the USA and another starting a first-rate private school for girls. Another woman inspired the birth of historic Savannah, and her sister wrote the *Savannah Cookbook*. Black entrepreneurs went into business for themselves and established middle-class communities.

Charles Herty in nearby Statesboro, Georgia, developed a method of extracting the sap from the pine tree without destroying the tree. This meant turpentine could be produced while the tree grew, and the tree could still be harvested at maturity. Men and women built Liberty ships during World War II. The industry employed 15,000 people and turned out 87 ships during the war years. Savannah shipbuilders could build a vessel in 40 days.

As some of the older buildings in the city were torn down to build parking lots and the corners were cut off of the squares to speed traffic, Savannah citizens woke up. They realized that the beautiful historic district did not need to be modernized. When they recognized that historic buildings would bring in tourist dollars, historical preservation became a priority. Historic Savannah was created, and many buildings were saved.

In 1978, the Savannah College of Art and Design was founded. Many local skeptics were pessimistic about the idea of starting an art college in the city. They said it could not be done, and it would never last. The first building purchased was the old Savannah Volunteer Guard Armory, in the heart of the historic district. From there, the college purchased many more buildings and used its historic-preservation students to fix them up. The students received firsthand experience, and Savannah was spruced up. Every building restored by the college looks more beautiful than old Savannahians ever remembered it. Local downtowners put up with students with green hair on skateboards because the historic district is thriving, and the neighborhoods feel safer with young people walking and biking around.

Juliette Gordon Low

In 1912, Juliette "Daisy" Gordon Low founded the Girl Scouts of the USA. Born into the Gordon family on Halloween night in 1860, her birthplace is a National Historic Landmark visited by Girl Scouts from all over the world every year. The date of her birth is celebrated by the Girl Scouts as Founder's Day. (Courtesy of the Juliette Gordon Low Birthplace.)

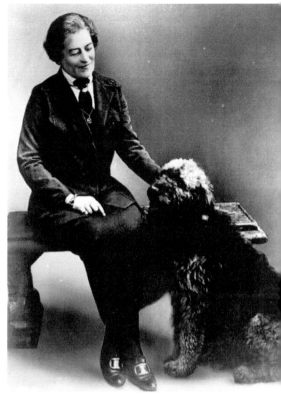

Juliette's Home

In England, Low was influenced by Sir Robert Baden-Powell, who had started the Boy Scouts. She returned to Savannah to start the Girl Guides, renamed the Girl Scouts in 1913. She called her cousin Nina Anderson Pape and told her of the idea that would influence girls everywhere. Together, they recruited girls and leaders from families all over Savannah, and it spread from there. (Courtesy of the Juliette Gordon Low Birthplace.)

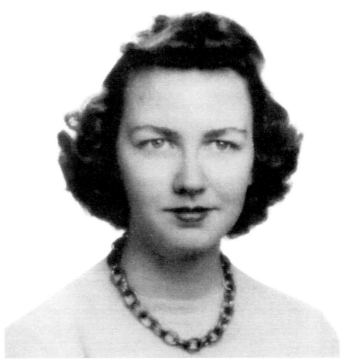

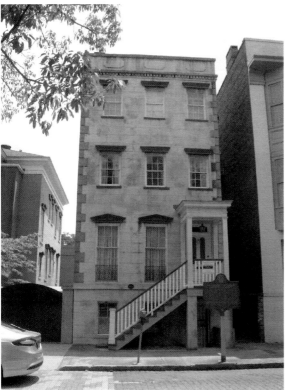

Flannery O'Connor

Flannery O'Connor was born in Savannah in 1925 and lived here until her family moved to Milledgeville when she was 13 years old. She is the author of novels *Wise Blood* and *The Violent Bear It Away* as well as 32 short stories and numerous essays. She is considered one of the best Southern writers by virtue of the morally flawed characters she created who sustain the qualities of hope and redemption.

The house where Flannery O'Connor was born at 207 East Charlton Street has been purchased and maintained as a tribute to the favorite Savannah author. The house is open to the public as a museum, and readings of her work and that of other authors are held on many Sunday afternoons. (Both, courtesy of the author.)

Lucy Barrow McIntire

Lucy Barrow McIntire, known as "Miss Lucy," loved writing poetry and acting in the theater, but more than that she loved standing up for the rights of others. She was most effective in improving social-welfare conditions, and she served on numerous boards and committees. McIntire helped establish a free lunch program in the public schools and advocated for women and children. She has been an inspiration to many young Savannah women, including her own granddaughters, who have grown up with an appreciation for the arts, a sense of responsibility for humanity, and a concern that all individuals are treated fairly and with respect. (Courtesy of Lucy Smith Brannen.)

Sarah Mills Hodge

Always interested in African Americans although white herself, Sarah Mills Hodge built the Mills Memorial Home for Aged and Infirm Negroes in honor of her parents in 1925. She also provided an endowment for the operation of the home on the corner of Ogeechee Road and Fortieth Street. Hodge also saw the needs of black children in the Yamacraw area, and she created the Hodge Memorial Day Care in memory of her husband. When she died in 1962, her will established the Hodge Foundation, which still keeps many community organizations operating. (Courtesy of Hodge Elementary School.)

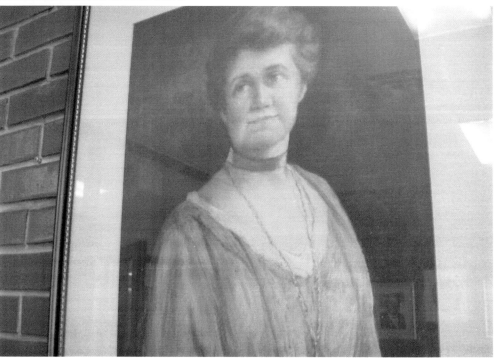

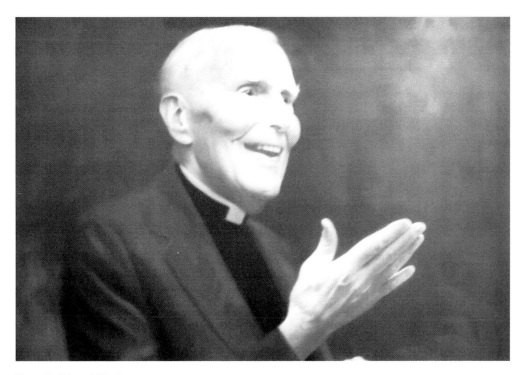

Rev. F. Bland Tucker

In 1895, Dr. Francis Bland Tucker was born in Norfolk, Virginia, to a distinguished family of Episcopal clergymen. His father, Beverley Dandridge Tucker, was the bishop of Southern Virginia, and his mother, Maria Washington Tucker, a collateral descendant of George Washington, was one of the last children to be born at Mount Vernon.

The youngest of 13 children, he married Polly Laird, the youngest of 12 children in another distinguished Episcopal Virginia family. Though they never had children of their own, they enjoyed their parishioners as their family everywhere they went.

The Tuckers arrived in Savannah after 20 years at a church in Georgetown, outside of Washington, DC. They were warmly welcomed at Christ Church in Savannah, where they remained for the rest of their lives. Before coming to Savannah, Bland Tucker had received a doctor of divinity degree from Virginia Seminary and was generally known as Dr. Tucker.

Dr. Tucker served on the commission to produce the 1940 Episcopal hymnal and contributed six hymns of his own. He served again on the 1982 hymnal commission and was the only person who served on both commissions. The 1982 hymnal has 26 of his hymns.

The Christ Church congregation has always been a mixture of the city's community leaders as well as those of lower incomes who lived in the neighborhood or other parts of the city. The Tuckers loved everyone equally, the bank presidents and civic leaders as well as those in reduced circumstances. Dr. Tucker was pleased when the sons of two of the community's important leaders decided to go into the ministry from Christ Church, Holland Clark and Charles Demere. Of course they both went to Virginia Seminary.

Dr. Tucker was a strong community leader in such a quiet and unassuming way that it was impossible not to go along with him. When the civil rights struggle hit Savannah in the 1960s, there were many people who objected to racial integration. Dr. Tucker was so patient and loving to everyone that much was accomplished with a minimum of resentment. The memorial service after the death of Dr. Martin Luther King was held at Christ Church for the whole community because Dr. Tucker was leading the way to make sure the atmosphere was one of love and acceptance for everyone's feelings. (Courtesy of Christ Church Episcopal.)

Ralph Mark Gilbert

Ralph Mark Gilbert was born in Jacksonville, Florida, in 1899. He came to Savannah in 1939 to be pastor at First African Baptist Church, where he continued to serve until his death in 1956. A graduate of the University of Michigan, Gilbert was a nationally known orator, tenor, and religious playwright. He organized Greenbrier Children's Center, a home for young black children and teenagers who needed a place to live. He also developed the West Broad Street YMCA, which provides educational and recreational programs for the black community. (Courtesy of the artist, Brigitte Pirlot.)

Ralph Mark Gilbert Civil Rights Museum

Gilbert's greatest contribution is his influence during the civil rights movement, which kept the group focused on nonviolent action. He served as president of the local NAACP from 1942 to 1950 and organized chapters in other cities all over Georgia. He was instrumental in launching a city-wide voter registration drive in which hundreds of black citizens were registered. He influenced the city leadership to hire the city's first black policemen; Savannah was one of the first Southern cities to do so. (Courtesy of the author.)

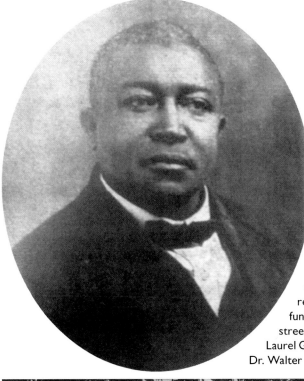

Capt. Eddy Seabrook

Capt. Eddy Seabrook was a licensed master river pilot, sailing along the Eastern Line from the St. Lawrence River to the Gulf of Mexico. Later he settled in Savannah and opened a funeral home on West Broad Street, now Martin Luther King Jr. Boulevard. He became one of Savannah's wealthiest and most respected black businessmen. Captain Seabrook owned a number of properties along West Broad Street, including this building at 514 that features a popular gaming restaurant. When he died in 1920, the funeral procession stretched out along the street until it reached his final resting place at Laurel Grove South Cemetery. (Left, courtesy of Dr. Walter Evans; below, courtesy of the author.)

Lucille Wright

Lucille Wright was born in Darien, Georgia, and learned how to cook from her mother. Born in 1917, Wright was taught the values of honesty, integrity, and hard work. She was the most popular caterer in Savannah, and many Savannah matrons planned their parties around when they could get Wright. She taught her two sons to be bartenders, and with their skills and respectful personalities they were highly sought after by any party-giver who might be uncertain about the correct way things should be done. Her tomato sandwiches are celebrated by many local guests who will always remember the gracious lady who served them. (Courtesy of Wilbur Wright.)

William Rogers

Lucille Wright's father was William Rogers, who served in the state legislature from McIntosh County from 1902 to 1907. During Reconstruction, a number of black legislators were elected, but they were soon discouraged from holding public office. William Rogers was the last black representative elected to the general assembly before blacks were legally disenfranchised in 1908. (Courtesy of Wilbur Wright.)

Joseph "King" Oliver

Joseph "King" Oliver was a jazz cornet player born near New Orleans, Louisiana, and he was heavily influenced by the city's music. He took Louis Armstrong into his band as a second cornet player, and the two men were friends for life. King Oliver fell on hard times and ended up penniless in Savannah. He spent his last days at a rooming house at 508 Montgomery Street in Savannah and is buried with other jazz artists in Woodlawn Cemetery in the Bronx, New York.

Boo Hornstein and others who loved his music placed a plaque on the wall of the courtyard at 514 Martin Luther King Jr. Boulevard in honor of King Oliver. Dr. Walter Evans owns the building, and he was there to celebrate when Winton Marsalis spoke at the dedication of the memorial. (Left, courtesy of Dr. Walter Evans; below, courtesy of the author.)

JOSEPH "KING" OLIVER
CORNETIST, COMPOSER, AND BANDLEADER
MENTOR OF LOUIS ARMSTRONG

Born: May 11, 1885
Died: April 10, 1938

A first-generation creator of the distinctively African American art form known as jazz, King Oliver spent his last earthly days in Savannah living at a nearby rooming house at 508 Montgomery Street and working at Wimberley's Recreation Hall located at 526 West Broad Street.

King Oliver's fame was raised among the great early New Orleans trumpet players. He moved to Chicago in 1918 where, five years later, his legendary "Creole Jazz Band" was the toast of that city. The band's second cornet was played by Louis Armstrong who considered King Oliver his inspiration and mentor. It was in or around Chicago that he made seminal recordings which remain unique testimony to his place among the early jazz pioneers.

King Oliver's legacy to jazz is outstanding. He composed such early tunes as "Dippermouth Blues," "West End Blues," and many other original titles. He was greatly admired as a bandleader having pioneered the trumpet mute and stylistic effects which remain a part of jazz improvisation to this day. He is one of the most important musicians of the New Orleans style, and was one of the first black musicians to appear on records for mainstream labels such as Victor, Columbia, Okeh, Gennett, and Brunswick.

Dedicated March 24, 2007 by Friends of King Oliver

Anna Colquitt Hunter

Anna C. Hunter left Agnes Scott College before graduating to get married, but her husband died young, leaving her with three children. Hunter went to work for the *Savannah Morning News* as a reporter, columnist, society page editor, book page editor, and editorial writer. Her older sister Hattie had been successful in the newspaper business and convinced her she was up to the challenge. Hunter lived in one of the old cotton warehouses overlooking the Savannah River before the riverfront was restored. She was a leader in historic preservation. (Courtesy of Michael Jordan and *Cosmos Mariner Productions*.)

Anna Colquitt Hunter, who called together six friends to establish Historic Savannah Foundation in 1955.

Painting by Anna C. Hunter

At the newspaper, Hunter was busy reviewing the arts, but she felt she could be a better critic if she were a painter herself. Undaunted by the fact that she had no training, Hunter painted local scenes that surrounded her, including houses and backyards and children playing in the street. She held a one-woman show in New York and others across the South. Her "sophisticated primitive" paintings are prized by her Savannah friends and relatives who still have them. (Courtesy of Christ Church Episcopal.)

Harriet Ross "Hattie" Colquitt
Harriet Ross "Hattie" Colquitt was part of a Savannah family although she lived across the river in Bluffton, South Carolina, in the Card House. Like her younger sister Anna Hunter, Colquitt made a living doing what she knew how to do: gathering recipes from the black women around her who really knew how to cook. The task was not an easy one, as the best Southern cooks perform like a New Orleans jazz band, improvising along the way. Her cookbook, like every good Southern cook, requires some improvisation for the best result. (Courtesy of the author.)

THE
SAVANNAH
COOK
BOOK

HARRIET ROSS
COLQUITT

Introduction by
OGDEN NASH

Nina Anderson Pape
Nina Anderson Pape was born in 1869 to a distinguished Savannah family. Her grandfather, Edward Anderson, was mayor of Savannah. "Miss Pape," as everyone called her, started her own school for girls, which held girls to high academic standards previously applied only to boys. The Pape School was Savannah's preeminent private girls' school for many years, and it evolved into the Savannah Country Day School, an outstanding school for both boys and girls. (Courtesy of Savannah Country Day School.)

Malcolm Maclean

Malcolm Maclean was a Yale graduate, a graduate from Harvard Law School, and a hero in World War II. As a partner in one of the most prestigious law firms in Savannah, he did not have to offer himself for public service. But the city had been run by a political machine for many years, and it was time for a more progressive point of view.

Malcolm Maclean was elected mayor of Savannah in 1960, after serving an unexpired two-year term, and the civil rights movement was just beginning. The city can boast of intelligent political leaders in the past, but few civil servants can boast an intellect or heart for public service comparable to Maclean's. He recognized that the policy of racial segregation was untenable, and he formed a committee of 100 community leaders to discuss what policies would be in the best interests of the city. In doing so, he preempted the racial violence that took place in other cities.

The committee quietly integrated the public library and the movie theaters. Gradually, black patrons were able to participate in activities and enjoy services that were closed to them before. But as the white community adjusted to the changes, some people became resentful and even hostile. They blamed the mayor for moving ahead too fast on integration, and when he ran for reelection in 1964, he was defeated.

Maclean returned to his law practice and managed the firm successfully for many years. One of the smartest things he did as a young man was to marry Frances Grimball from Charleston and raise two children. He was active in his church, Christ Episcopal Church, and served as chancellor of the Episcopal Diocese of Georgia.

Because of his keen intellect, he saw things as black or white, right or wrong, and to some people he seemed abrupt. As the answer to something was so obvious to him, he often responded with one-word answers, annoying people who preferred a lengthier, more nuanced response. But his legacy will be that of a great leader who forced a community to address the inevitable social change of the 1960s with civility, humanity, and respect for the law. (Courtesy of Frances Maclean.)

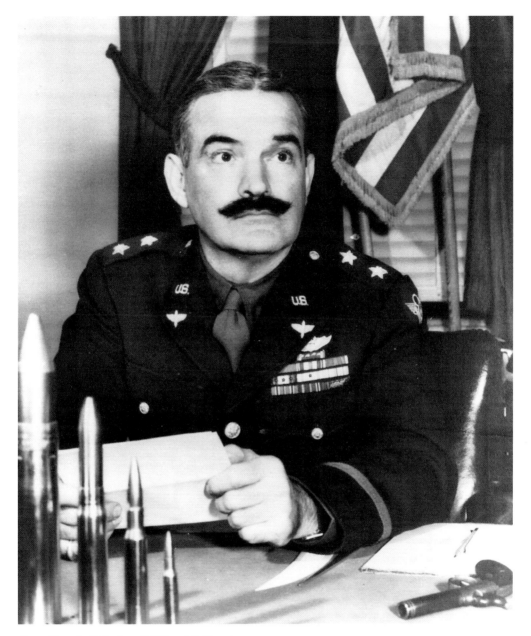

Gen. Frank O'Driscoll "Monk" Hunter

Gen. Frank O'Driscoll "Monk" Hunter was born in Savannah in 1894 and had a distinguished military career in the Air Force. He went to France in 1917, and on his first combat patrol he downed two German planes and landed safely despite being wounded. By the end of the war, he had downed nine German planes and was hailed as a World War I ace.

General Hunter continued his distinguished military career in World War II, and Hunter Army Air Field in Savannah is named for him. Throughout his lengthy flying career, he survived three bailouts, one of which was from an altitude of 500 feet over a frozen lake, and two broken backs, both of which kept him in the hospital for a year. Hunter never married, but many Savannah ladies enjoyed his company over the years at community social events. (Courtesy of Pearce and Joyce Connerat.)

Florence Martus

Florence Martus was born in 1868 on Cockspur Island, where her father was an ordinance officer at Fort Pulaski. She moved with her brother to nearby Elba Island, where he was the lighthouse keeper. She loved to salute the ships, and she waved at every one that entered or left the port between 1887 and 1931. She waved a handkerchief by day and a lantern by night. She became a legend, and her story was told in ports all around the world. (Courtesy of the author.)

CHAPTER SEVEN

Present Day

After World War II, Savannah entered a period of economic prosperity. New factories were built, opening doors of opportunity for returning servicemen. Schools, restaurants, and theaters were still segregated, but Truman's integration of the military had begun to change some people's attitudes. Mechanization of farm equipment reduced the number of farms, and many rural families moved to Savannah. The city's residential district had spread to the south side of town, and many old homes in the historic district were allowed to deteriorate.

When Historic Savannah Foundation was formed, many valuable old buildings were saved. A few were lost, such as the DeSoto Hotel and the Union Station, but many were saved thanks to Walter Hartridge, the Adlers, and others. Savannah went through the civil rights struggle but not as painfully as some places, thanks to progressive leadership in the white and black community. Malcolm Maclean's idea of the Committee of 100 forced white city leaders to meet with black leaders to discuss integration. The result was the quiet integration of the library and theaters, a bold move that cost Maclean the next election. W.W. Law withstood criticism from the black community that he did not fight hard enough and was moving too slow. He continued to advocate for civil rights and made a great contribution with his knowledge and dissemination of African American history.

Today, Savannah has become a significant tourist destination, and visitors are greeted with traditional Southern hospitality. The city continues to attract people with its rich architectural heritage and natural beauty. It is an easy city to walk around in, as the original Oglethorpe plan is maintained with the parks and squares. The house museums are all worth visiting, River Street is a great treat, and Moon River coalition provides an opportunity to experience the Lowcountry beyond the city.

As unusually beautiful and special as the city is, it is the people who are most enjoyable. There are writers, artists, musicians, sculptors, woodworkers, cooks, and creators of all kinds. One can find them in the city market, on the street, in their studios, or anywhere that the Savannah College of Art and Design is holding an event. There are a number of young people who have left Savannah to become famous in fields of art, music, science, and literature. But the city attracts and holds people who want to live in a place where people of all ages and races enjoy living and working together. Savannah is a beloved community.

Conrad Aiken

Conrad Aiken was born in Savannah in 1889, the oldest of the four children of Dr. William Aiken and his wife, Anna, the daughter of a Unitarian minister. When Conrad Aiken was 11 years old, his father killed his mother and then killed himself. Aiken left Savannah and went to live with an aunt in Cambridge, Massachusetts, where he later attended Harvard University and made friends with T.S. Eliot. Over a period of 50 years, Aiken published poems, essays, short stories, novels, and literary criticism. He won a Pulitzer Prize in 1930 for *Selected Poems*, and he and his wife, Mary, are buried in Bonaventure Cemetery beside his parents.

After Conrad Aiken's death, his widow placed a bench at the cemetery with an inscription that reads "Cosmos Mariner, Destination Unknown." Visitors love to see it, although drinking martinis from red votive candle holders at the spot as the Aikens did is no longer allowed. (Both, courtesy of the author.)

Richard R. Wright

Richard Wright was an American military officer, college president, civil rights leader, and banking entrepreneur. Wright was born into slavery in a log cabin outside of Dalton, Georgia, in 1855. He attended one of the schools set up for free blacks after the Civil War and graduated from Atlanta University; he was the valedictorian at the school's first commencement ceremony in 1876.

In 1898, Pres. William McKinley appointed him a major in the US Army, and he was the highest-ranking African American officer in the Spanish American War. In 1891, Wright became the first president of the Georgia State Industrial College for Colored Youth, which became Savannah State University. He served as president for 30 years, developing a curriculum that included the classical liberal arts as well as vocational studies and self-reliance concepts.

In 1921, he left Savannah State to study banking at the Wharton School in Philadelphia and created the first African American–owned bank in Pennsylvania. The bank grew and lived on for many years after his death in 1947.

Richard Wright married Lydia Elizabeth Howard of Columbus, Georgia, in 1876, and they had nine children. One of their sons, Richard Wright Jr., was in the first graduating class at Georgia State Industrial College in 1898. He studied at the University of Pennsylvania and was the first African American to earn a doctorate there. He became a college president and a bishop in the African American Episcopal Church. One of Richard Wright Jr.'s daughters, Dr. Ruth Wright Hayre, also earned a doctorate at the same university as her father. (Courtesy of the Library of Congress.)

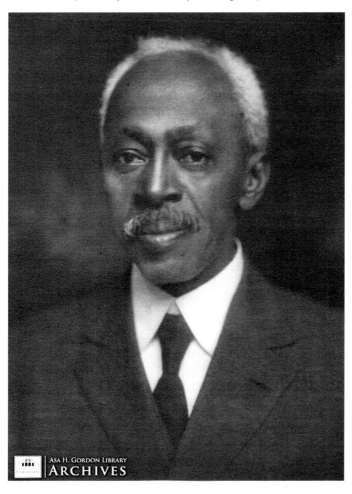

ASA H. GORDON LIBRARY
ARCHIVES

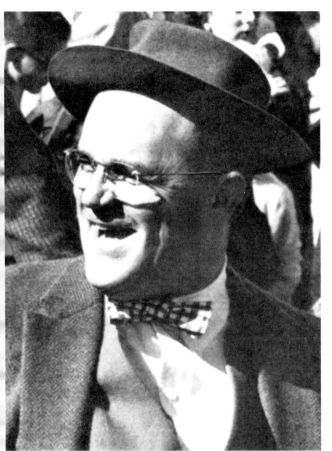

Mills Bee Lane Jr.

Mills Lane lived in Atlanta but loved Savannah, the city of his birth. "My father owned the joint" was Lane's explanation for his success at the C&S Bank, but his modesty and humor belied his skills and hard work. As president of the bank he was a champion of new ideas, introducing the concept of instant banking and credit cards. He and his wife, Anne, retired to Savannah, restoring several downtown squares as well as his home in the historic district. (Courtesy of Howard Morrison Jr.)

Gold Dome on Savannah's City Hall

In Atlanta, Mills Lane pushed the business community to make Atlanta the business leader of the South. He painted Atlanta's capitol dome gold and continued his philanthropic acts in Savannah as well. When the local college considered tearing down some historic buildings to expand their downtown campus, he purchased a sizable tract of land on the south side of the city, saving the buildings from demolition. (Courtesy of the author.)

Mills Lane IV

Mills Lane IV continued his father's philanthropy and contributions to historic preservation. He was born in Atlanta to Anne and Mills Bee Lane Jr., but Savannah became the beneficiary of his philanthropic endeavors. He founded *Beehive Press* when he was only 28 years old and published many beautifully written and illustrated books on Georgia gardens, history, and architecture.

He loved his tastefully restored house on Pulaski Square, and he built a new house in a typical Savannah style on another corner of the square. He built a second new house on the same square, on Charlton Street, in traditional 19th-century style. He undertook the Bull Street Improvement Project, using his own money to renovate the most important street in the historic district with brick sidewalks and landscape. (Above, courtesy of the Beehive Foundation; below, courtesy of the author.)

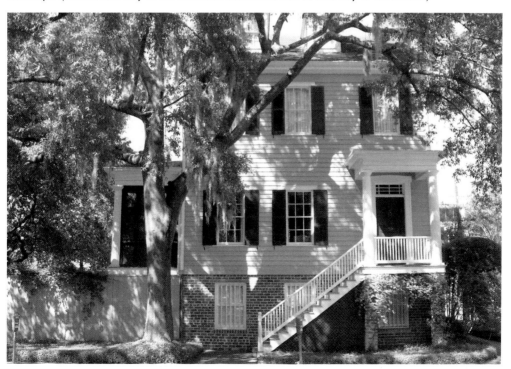

Ships of the Sea Museum
Mills Lane IV moved and greatly improved the Ships of the Sea Museum, founded by his father. Perhaps Lane's greatest contribution was the restoration of the historic Scarbrough House and the establishment of the Ships of the Sea Museum there. The museum holds models of ships and other maritime artifacts as well as the largest garden in the historic district. Embedded in the floor at the entrance to the north garden is a plaque to honor his memory. (Both, courtesy of the author.)

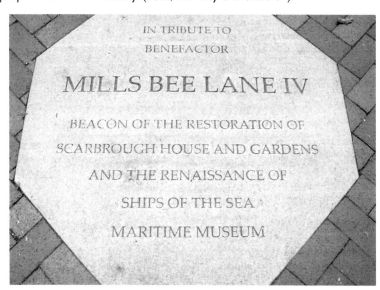

Emma and Lee Adler
Emma and Lee Adler are Savannah natives who were among the first to recognize that its historic district was worth preserving. Lee Adler helped Historic Savannah get organized and served as its first president in 1959. He served on the board of the National Trust for Historic Preservation and was presented with its highest honor, the Crowninshield Award. (Courtesy of Emma Adler.)

Massie School
One of Emma Adler's projects was saving of the historic Massie School in 1975 after it was closed as a public school. She formed the Friends of Massie, which helped raise funds for the restoration of the building as a heritage education site. Today it is open to the public as a popular tourist spot to learn about Savannah history. (Courtesy of the author.)

Westley W. Law

W.W. Law was born in Savannah in 1923 to a family who taught him the value of hard work and perseverance. His mother and grandmother instilled in him a love of reading and a sense of justice. His mentor was Ralph Mark Gilbert, the pastor at First African Baptist Church, and he was also influenced by his Scoutmaster, John S. Delaware. He served in the Army during World War II and used the GI Bill to go to college and graduate from Georgia State College. (Courtesy of the City of Savannah, Research Library and Municipal Archives.)

Westley W. Law and His Mother, Geneva Law
Law and his mother are pictured here in front of the King Tisdell Cottage Museum. Law was active in the local NAACP and brought a lawsuit to desegregate the local public schools. He became interested in history and recognized the value of preserving Georgia history for future generations. He was influential in establishing the Ralph Mark Gilbert Civil Rights Museum, the Negro Heritage Trail, the King Tisdell Cottage Museum, and the Beach Institute of African American Culture. (Painting by and courtesy of Dr. Preston Russell.)

Walter Charlton Hartridge

Walter Hartridge was born in Savannah and loved the city from the beginning. To walk with him through the streets of Savannah was to learn the history of each house and hear the stories of the families who lived in them. A Harvard graduate, Hartridge and his family lived in the historic district before it became fashionable. Hartridge and his love of the city were the inspiration for Savannah's historic preservation movement. (Courtesy of Walter Hartridge Jr.)

James McPherson

Born in Savannah in 1943, James McPherson was the first African American to win the Pulitzer Prize for fiction, in 1978. He won the prize for his collection of stories *Elbow Room*, but his memoir, *Crabcakes*, is also beautifully written. He describes life in Baltimore, Maryland, and the pleasure of eating such a delicacy, but he also refers to the memories of growing up in Savannah. He says that 86, the number of the paper route that he walked as a boy in Savannah, is still his lucky number. (Courtesy of the author.)

Anne Stewart

Anne Stewart had noticed that some European cities had a place referred to as hospice, where individuals were allowed to spend their last days dying with dignity. She felt there should be a place like that in Savannah. She rallied medical people and volunteers and became Hospice Savannah's first executive director in 1981. Today, a homelike 28-bed inpatient medical facility is available to any patient with medical issues that cannot be handled at home. Hospice also provides respite for weary caregivers. (Courtesy of the author.)

Dr. Augustus "Gus" Oemler

Dr. Gus Oemler is one of those brilliant Savannah men who left home and made a significant contribution in his field of interest. Oemler graduated from Princeton University in 1969 and received a master's degree and doctorate from Caltech in 1974. He did graduate work in astronomy at Kitt Peak National Observatory in Arizona and joined the faculty at Yale University. After many years as a professor and chairman of the Department of Astronomy at Yale, Oemler left to take over as chairman of the Observatories at Carnegie Institution in Pasadena, California. His primary research interests have been the evolution of galaxies and the large-scale structure of the universe. (Courtesy of Dr. Augustus Oemler.)

Dr. Jason Morgan

Before he became a famous scientist, Jason Morgan grew up in Savannah. Morgan graduated from Georgia Tech with a degree in physics in 1957, and he went on to Princeton, where he received his doctorate in 1964. He immediately joined the faculty at Princeton and taught there for many years. Morgan made a significant contribution to the theory of plate tectonics when he explained the alternating polarity of layers on the ocean floor along the mid-Atlantic ridge. His paper published in 1968 is considered the basis for the work of many geologists and geophysicists since that time. Dr. Morgan has received many honors and awards, including the National Medal of Science from Pres. George W. Bush in 2003. (Courtesy of Dr. Jason Morgan.)

J. Robert "Bob" Paddison

Bob Paddison and his wife, Philippa, are the quiet people behind the scenes who do not care about taking credit for anything. When Bob retired from his banking career, he wanted to help the public schools. He could have run for school board president, but that was not exactly his niche. He loved photography, was quite good at it, and wanted to share it with some students.

Bob chose DeRenne Middle School and agreed to come as a volunteer. He took three or four students and taught them how to take photographs. The school had a space that was a perfect darkroom, and over the years, the school has turned out hundreds of amateur photographers who have acquired a skill that will last a lifetime.

For 23 years, Bob has volunteered every day to teach photography to middle school students. In his spare time, he has served for almost 50 years on the board of Wesley Community Centers—that is, when he is not serving on the public library board or the homeless authority. In the meantime, he and Philippa raised four children who attended public schools and turned out to share their parents' love of giving back to the community. (Photograph by and courtesy of Diana Churchill.)

Dr. Martha Fay

Dr. Martha Fay moved to Savannah with her husband, Richard W. Fay, in 1944. She was born in Fort Smith, Arkansas, before women could vote, and she completed her doctorate in genetics at the University of Illinois. She taught biology and chemistry at Armstrong College before it was part of the University of Georgia, and she played an important role in public health in Savannah.

She spent her life in community service while her husband worked as a researcher with the US Public Health Service. When he served with the World Health Organization in Egypt for four months, she kept her volunteer work going and managed the three children. When he was stationed in Switzerland for two years, she packed up the family and joined him in 1959.

When they returned to Savannah, she served on the Savannah–Chatham County School Board, on the board of public health, and as the project administrator of the child evaluation center. She was influential in calling attention to the problem of mental health and bringing Tidelands Mental Health treatment center to Savannah.

Dr. Fay was honored in 2008 when the new Chatham County Health Department was named for her. As she sat on the podium at age 95, she enjoyed listening to accolades from Savannah citizens from all walks of life who described how they enjoyed working with her. (Courtesy of Libby Fay and David Mustoe.)

Anne and Sigmund Hudson

Anne and Sigmund Hudson are Southerners from Mississippi and Tennessee who moved to Savannah in 1971 to teach mathematics. They both received their doctorates at Tulane University in 1961 and 1963. Anne became a professor of mathematics and computer science at Armstong College, and Sigmund took the equivalent position at Savannah State College. At that time, a married couple were not allowed to teach in the same department at a state university.

Anne and Sigmund joined St. Matthew's, a black Episcopal church, and have worked quietly in the community against poverty and racism. They have always believed in the value of public education, sending their twin boys to local public schools. Anne plays the piano at the 8:00 a.m. service at St. Matthew's, and Sigmund volunteers on the governing board of the church. Also, Sigmund has volunteered to help restore the stones and markers in the black section of Laurel Grove Cemetery, where much information has been lost to neglect.

The Anne and Sigmund Hudson Mathematics and Computing Colloquium was their brainchild, and the series is named for them. Students, faculty, and anyone interested in discussing ideas of higher mathematics meet for lunch of a hot dog or salad. The cost is $1, so that, in keeping with the Hudson philosophy, no one who wants to be there is prohibited for financial reasons from joining the group. (Courtesy of Drs. Anne and Sigmund Hudson.)

Laura Devendorf

Laura Stevens was born in Savannah and grew up here, but the town could not hold her long. Laura lived in California as an artist and art critic, raised three children, designed Olympic equestrian courses, and figured out how to preserve her family's 10,000-acre property in Liberty County. She inherited Melon Bluff from her parents, but it would take determination, ingenuity, and hard work to preserve the coastal Georgia land and hold off the developers.

After her husband, Art Devendorf, died, Laura Devendorf and her daughter Meredith established Seabrook Village to preserve the cultural history of the area and protect the unique coastal environment of Melon Bluff. They established the Springfield Legacy Foundation, a consortium between the University of Georgia and other educational groups, to protect the area as a nature preserve.

More recently, Devendorf has written a cookbook with her daughter and a collection of short stories. Her latest book, *Killing with Kindness*, is fiction, but readers will find stories that are familiar to people in coastal Georgia. Laura and Meredith have opened Dunham Farms, a bed-and-breakfast with a banquet room big enough for dinners and receptions. (Courtesy of Laura Devendorf.)

John Kirk Train Varnedoe

Kirk Varnedoe's family was different to start with. His parents, Sam and Lilla Varnedoe, had black guests to their dinner parties long before anyone else would have thought of it. Kirk's older siblings, Sam, Gordon, and Comer, were always having fun and doing interesting things. Kirk attended Savannah Country Day School and St. Andrew's School and graduated from Williams University. After college, he lived in Paris and became an expert on Auguste Rodin. He married sculptor Elyn Zimmerman and taught art history at Stanford University, Columbia University, and New York University's Institute of Fine Arts.

In 1984, he was awarded a MacArthur Fellowship and collaborated with William Rubin on an important and controversial exhibit at the Museum of Modern Art in New York. Four years, later he became chief curator of painting and sculpture at MOMA, a position he held for 13 years. Varnedoe left MOMA to become a scholar in residence at Princeton University, a position he held for two years until his death at age 57. (Courtesy of Comer Varnedoe Immel and Catherine Varnedoe.)

Eleanor "Sandy" Torrey West

Eleanor "Sandy" Torrey was born in 1913 to wealthy parents who lived in Grosse Pointe, Michigan. In the winters they came to Savannah and stayed at Greenwich, their 40-room mansion next to Bonaventure Cemetery. Sandy loved Greenwich with its pink sphinxes in front and rides in a cart pulled by her goat. When the house caught fire, she and her nurse barely escaped by jumping from a second-story window.

The next year, her parents bought nearby Ossabaw Island, and Sandy did not expect to love the island as much as she had loved Greenwich. However, she did fall in love with the remote island with its green marsh and sandy beaches. She made friends with the wildlife and native plants she discovered on the island, and she became a part of the natural environment. Sandy opened her home to writers, poets, musicians, and artists who wanted a place to stay to work on their creative projects. When the money ran out, she made a deal to sell the island to the State of Georgia with the stipulation that it would be used only for educational purposes. Ossabaw would never be developed like other nearby islands, and Sandy could live in her house for the rest of her life.

At 102, Sandy has passed the headaches of managing the island on to the Ossabaw Island Foundation. She continues to live in her house and welcomes visitors who come over for fundraisers to eat barbecue and spend the day, exploring the special place that will always remain her unspoiled island refuge. (Photograph by and courtesy of Robert S. Cooper.)

Dr. Paul Pressly

Paul Pressly was born in Chattanooga, Tennessee, where his father was headmaster at McCauley School. Education was clearly a priority in the Pressly family, and Paul has degrees from Princeton, Oxford, and Harvard Universities. He came to Savannah to take the position as headmaster at Savannah Country Day School, which he led successfully for over 20 years.

Dr. Pressly's interest in education extended from the private school students to whom he was committed to Savannah's public school students, for whom he founded a summer enrichment program. After his retirement as headmaster, he took a position with the Ossabaw Island Foundation, whose goal is to promote and develop educational, scientific, and cultural programs for the nearby barrier island. His work as director of the Ossabaw Island Education Alliance has brought students, professors, and others from around the world to the island for research and conferences.

Dr. Pressly explored the link between the slaves who worked on the plantations on Ossabaw Island and the present-day residents of Pin Point, a community on the mainland nearby. The Pin Point community was established by former slaves who left the island after two devastating hurricanes in the 1890s. Dr. Pressly organized a reunion of Pin Point residents at Ossabaw, transporting them over by boat. There he collected oral histories from those who remembered growing up on the island as children.

The Pin Point Heritage Museum has been established to tell the story of this community, and the Sweetfield of Eden Baptist Church down the road has roots going back to the Hinder Me Not Church on Ossabaw Island. Dr. Pressly has written a book, *On the Rim of the Caribbean: Colonial Georgia and the British Atlantic World*, a scholarly work that talks about the influences on the plantation life of early Georgians in the Colonial days. (Courtesy of Dr. Paul Pressly.)

Rev. Susan Harrison
Susan Wolfe Harrison was born in Pittsburgh, Pennsylvania, and she came to Savannah when she married native Savannahian Robbie Harrison. A graduate of Smith College in Northampton, Massachusetts, Susan made friends in Savannah and volunteered as president of the junior league. She was one of the founders of the soup kitchen Emmaus House as well as the coalition for the homeless. Her caring for those less fortunate and her deep sense of spirituality led her to be ordained as a deacon at Christ Church Episcopal, the first woman ordained in the Episcopal Diocese of Georgia. (Courtesy of Robert L. Harrison.)

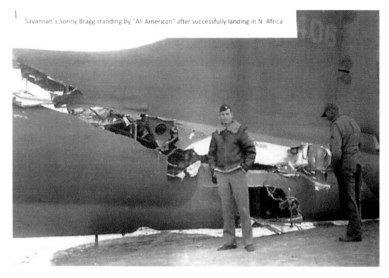

Savannah's Sonny Bragg standing by "All American" after successfully landing in N. Africa

Kendrick R. Bragg

Kendrick R. "Sonny" Bragg was born in Savannah and entered the Air Force in time for World War II. In 1943, Sonny was on a bombing mission over North Africa when his plane was hit by an out-of-control enemy fighter that crashed into the rear fuselage of his plane. The plane was almost completely severed, but Sonny was able to fly his B-17 Flying Fortress, the *All American*, back to home base, saving the whole crew.

This photograph of the *All American* in flight became the most famous aerial shot of World War II. It was taken by Charles C. "Cliff" Cutforth, the navigator of one of the other Flying Fortresses flying in formation.

Earlier that morning, Elton Conda was sitting in the mess hall at the Army base in Biskra, Algeria, when Sonny Bragg walked in. His gunner was ill, and he needed someone. "You'll fly with me today," Sonny said to the other soldier. The brash young soldier replied, "Can you fly the damn plane?" "Sure," Sonny replied. "Can you shoot the damn guns?" That day, Elton Conda found out just how well Sonny Bragg could fly. (Above, courtesy of the National Museum of the Mighty Eighth Air Force; below, courtesy of Jack Lee.)

Savannah's Sonny Bragg in left seat of "All American" over N. Africa WWII after collisions with German fighter plane

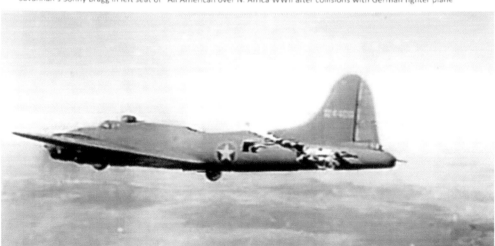

Albert Scardino

Born in 1948, Albert Scardino was the third of the seven children of Kay and Dr. Peter Scardino. Always bright and intellectual, Albert had a mischievous side that sometimes got him into trouble. At Savannah Country Day School, he and his friends rewired some electronics that caused music to come out into all the classrooms at the same time smoke bombs went off outside. He could have gotten expelled, but somehow he convinced someone in authority that his skills were needed to edit the yearbook.

Albert went on to Columbia University, and after graduation, he took a job as a wire service reporter in Charleston, West Virginia. There he met his editor, Marjorie Morris, whom he married in 1974. After he and Marjorie produced a documentary for PBS about the Georgia coast, *Guale*, they returned to Savannah in 1976 when Marjorie began to practice law. They revived the state's first weekly newspaper, the *Georgia Gazette*, winning a Pulitzer Prize.

Albert and Marjorie moved to New York in 1985, where he joined the *New York Times* as a reporter and editor, and she became the US publisher of London's *Economist*.

Albert's sense of humor continues to make him one of the funniest people in the world to have a conversation with. When asked about serving as Bill Clinton's campaign press secretary in New York in 1992, Albert said that job lasted about 20 minutes. Looking back on it, maybe he should not have insisted they ride the subway to meet people. When they got on with 200 people, including reporters, cameramen, and secret service, there were only five other people on the subway—two people late for work and three drunks. Never one to boast about his own accomplishments, Albert says, "I have a lot to be modest about."

Today Albert and Marjorie live in London, but they spend much of their time in the United States. Albert is chairman of the board of Immunovaccine, a company developing breakthrough vaccines for cancer and infectious diseases, and Marjorie chairs the MacArthur Foundation and serves on the boards of British Airways and Twitter. "I had to ask my children how to send a tweet before I accepted," said Marjorie. (Courtesy of Albert Scardino.)

Mary Helen Ray

Mary Helen Ray helped save Savannah's tree canopy. Mary Helen was born in Oklahoma, and she and her husband, George Ray, moved to Savannah in 1959. Always interested in gardening and environmental education, she was certified in historic gardens and tree landscapes. She was instrumental in starting the Savannah Tree Foundation, a group that helped to preserve many of the city's old live oaks. She served as the chair of the Savannah Park and Tree Commission for 17 years, and a bench was dedicated in her honor in the Colonial Park Cemetery. (Courtesy of Patricia Ray.)

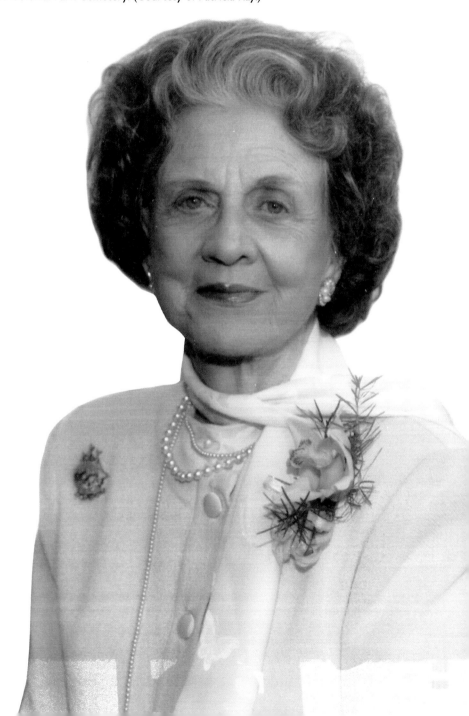

Ben Tucker

Ben Tucker's music filled the streets of Savannah. Tucker and his wife, Gloria, moved to Savannah in 1972; he had played bass with jazz greats like Quincy Jones and Herbie Mann in New York and thought he was ready to retire to a quiet life in Savannah. Ben and Gloria restored an old house on Jones Street in the historic district, and he spent time at the radio station WSOK, which he owned. Ben Tucker opened a jazz club called Hard-Hearted Hannah's, where his trio played six nights a week. Emma Kelly came over from Statesboro, and anything she played by ear on the piano Ben was able fill in on bass.

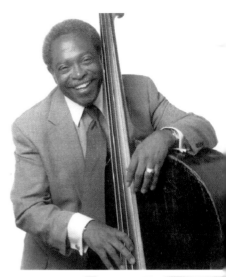

At Ben's funeral, the crowd followed the jazz musicians out of the church, down the street, and around the corner to the recently restored Ellis Square in a real New Orleans–style funeral procession. His legacy will be all the young people who love golf and music who want to be like him. (Both, courtesy of Gloria Tucker.)

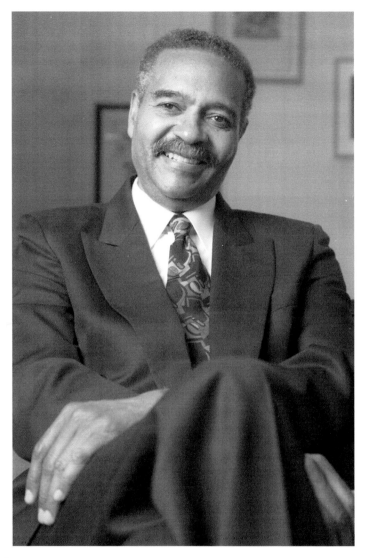

Dr. Walter Evans

Walter Evans was born in Savannah and attended public schools before going to Howard University in Washington, DC. After graduating from medical school at the University of Michigan, he practiced medicine as a surgeon in Detroit, Michigan, for 25 years. He admired the work of Jacob Lawrence and purchased a portfolio of 22 silkscreen prints called *The Legend of John Brown*. Walter Evans had begun what was to become one of the largest private collections of African American art in the country.

Dr. Evans noticed that museums were seriously lacking in exhibits of work by African American artists, and he set out to establish his own collection. "Buy what you like" was his advice to other art collectors, "and then you don't have to worry if the piece never increases in value." But Dr. Evans's motive in collecting was not for the purpose of investment—it was to enjoy and share with others the fine quality of work produced by African American artists that might otherwise remain unnoticed.

Evans and his wife, Linda, established a traveling exhibition from the art collection that has traveled across most of the United States. More recently, a large part of the collection has been donated to the Savannah College of Art and Design to become the centerpiece of the Walter O. Evans Center for African American Studies. (Courtesy of Dr. Walter Evans.)

Augusta Oelschig

Augusta Oelschig was born in Savannah in 1918. She attended schools in Savannah and studied art with Lamar Dodd at the University of Georgia, where she graduated in 1937. She held her first solo exhibition of paintings at the Telfair Academy in 1941. She married in 1947 and took an extended honeymoon to Mexico, where she studied with Mexican muralists. In 1947, she and her husband moved to New York. She studied at the New School for Social Research and exhibited at local galleries. She was interested in race relations and social justice, and her paintings reflect Southern society and the problems of racial injustice; one of her murals was moved to the chamber of commerce building on Bay Street. (Courtesy of the Oelschig family.)

Johnny Mercer

Johnny Mercer is pictured here with his daughter Mandy (left) and his niece Nancy Gerard. Johnny and his younger sister Juliana spent the summers at the family home at Vernon View on the Burnside River. He loved listening to the music and Gullah accents of the black families who lived and worked nearby. He listened to the servants who sang in the kitchen and the men who worked outside, and he visited black churches.

Mercer went to New York, where he met Ginger Meehan, whom he married in 1931. He won a contest to sing with the Paul Whiteman orchestra, and Whiteman encouraged him over the years. He wrote and sang "Pardon My Southern Accent," and then paired with Hoagy Carmichael to write "Lazybones." Over the years, he collaborated with a number of talented musicians, writing lyrics to over a thousand songs.

Mercer died in 1976 and is buried in Bonaventure Cemetery in Savannah next to a bench with the names of many of his songs. He and his wife have song names on their headstones, as does his niece Nancy, who is buried next to them. (Courtesy of Armstrong State College Library.)

Waddie Welcome

Walt "Waddie" Welcome was born in Sylvania, Georgia, in 1914. He moved with his parents and five brothers and two sisters to Savannah in the 1920s. They settled in the Cuyler community, just southwest of downtown Savannah. Waddie's mother, Carrie Welcome, ran a treats store from her front porch. Waddie, who had cerebral palsy, lay on a pallet on the porch guarding the goods. If someone took a cupcake or a brownie without putting money in the jar, Waddie would raise a ruckus to alert his mother.

Waddie Welcome lived with his family for 70 years, outliving his parents. His brother Willie and church friend Addie Reeves helped out, but Welcome was placed in a nursing home first in Savannah, then in Abbeville, Georgia. Susan Earl and Tom Kohler wrote *Waddie Welcome and the Beloved Community*, which tells the story of the community of people who brought Welcome home to live out his last years in Savannah, surrounded by people who loved and were inspired by him. His story, like that of the book's authors, is a story of friendships that transcend divisions of disability, race, and income. (Courtesy of Tom Kohler.)

Stratton Leopold

Stratton Leopold was born in Savannah in 1943 and lived upstairs with his parents over their popular restaurant and ice cream parlor. All the ice cream was homemade, and tutti-frutti became a local tradition. Leopold graduated from Benedictine, the local military high school, and pursued pre-medical in college. However, acting and film had an irresistible appeal for Leopold. He began his career when John Rousakis was mayor, and filmmakers were encouraged to produce their films in Savannah. Leopold had small acting parts, served as locations manager, and headed to California to became a film producer.

Leopold always loved his hometown, and he encouraged film companies to shoot their films in Savannah. He was instrumental in having a number of movies filmed here, including *The General's Daughter*, of which he was the executive producer. Leopold was the executive vice president at Paramount Pictures and has over 60 film and television credits to his name.

Leopold and his wife, Mary, returned to Savannah and reopened Leopold's Ice Cream, his father's and grandfather's business, which originally opened in 1919. The popular location in the historic district always has a line going out of the door as well as customers enjoying all the movie memorabilia decorating the inside of the shop. Leopold saved many of the fixtures and equipment from the original shop on Gwinnett Street, so there is plenty to see inside while sitting and enjoying a delicious dessert.

When not working in Los Angeles or other cities around the world, Leopold can be found scooping his own ice cream at Leopold's. He and Mary live on the Vernon River, just eight miles south of Savannah's historic district. (Courtesy of Mary and Stratton Leopold.)

Ted Turner

Ted Turner was a popular debutante escort in Savannah, and he later won the America's Cup. Turner grew up across the river in South Carolina, but he came over frequently to spend time with his friends in Savannah. His favorite activity was sailing his Lightning in the races at the Savannah Yacht Club and winning. Turner began his career as an account executive with Turner Advertising Company and headed to Atlanta. His sharp business skills and vision for the future made him successful in many business ventures.

In 1976, Turner purchased the Atlanta Braves, and he purchased the Atlanta Hawks basketball team the following year. A few years later, his company, Turner Broadcasting Company, started a revolution in television with the introduction of CNN, the first 24-hour cable news network in the world.

Turner created the Ted Turner Foundation, which is one of the largest philanthropic organizations in the world. The goals of the foundation are to support efforts for improving air and water quality, develop a sustainable energy future to protect our climate, maintain wildlife habitat protection, and curb population growth rates. The foundation has given over $300 million to hundreds of organizations to further these goals.

In 1997, Turner pledged $1 billion to the United Nations Foundation to promote a more peaceful, prosperous, and just world. The goals focus on areas of women and population, children's health, the environment, and peace and security.

Today, Turner's company, Turner Enterprises, Inc., manages two million acres in the western United States and Argentina. He also manages the largest commercial bison herd (51,000) in North America, located in Colorado and other western states.

Turner brought national attention to the America's Cup in 1977 when he won the race with his Savannah crew. All his Savannah friends remember parties with him and celebrations at the yacht club. In this photograph, he is escorting his longtime friend Polly Wylly Cooper with Tim Cooper (left) at the debutante ball in 1959. (Courtesy of Polly Cooper.)

Georgia Benton

Georgia Benton is the first African American woman to join the Savannah chapter of the United Daughters of the Confederacy. A Savannah native, she grew up hearing stories about the Civil War service of her great-grandfather George W. Washington, a slave from Sumter, South Carolina. Washington entered Confederate service at age 16 in 1862 as the body servant of Lt. William Alexander McQueen, who was 22 years old.

Washington followed his master to the battles of Sharpsburg, Gettysburg, and Petersburg and then brought McQueen's body home for burial when he was killed during the last days of the war. After the war, Washington worked for the A.A. Solomons family in Sumter as a butler and valet for 40 years. When he died in 1911, the Solomons family put up a four-foot monument at his grave in Walker Cemetery in Sumter. Georgia Benton remembers visiting the gravesite as a child.

Benton has spent much of her life as a teacher in Savannah's public schools. She feels that her great-grandfather's Confederate service is a part of the untold history of the South. She is pleased to be a member of the United Daughters of the Confederacy and honor her heritage along with others who are proud of their ancestors' Confederate service. (Courtesy of the author.)

John Rousakis

John P. Rousakis had a personality that attracted people from all walks of life. He was Savannah's longest-serving mayor, serving five terms and 16 years between 1970 and 1991. He was the son of Greek immigrant parents and spent his youth working for his parents at Paul's Soda Shop on Bull Street. He was responsible for much of the downtown revitalization, particularly city market and River Street. The plaza on River Street in front of the city hall is named in his honor. (Courtesy of the City of Savannah, Research Library and Municipal Archives.)

Gerald Chan Sieg

Gerald Chan Sieg was a native Savannahian from one of the city's oldest Chinese families. She had a great sense of fashion and advised women at Fine's Department Store on Broughton Street. As advertising director at Fine's, she produced simple but elegant advertisements for the *Savannah Morning News*. She added style to the Savannah Symphony fashion show and used her skills to benefit other organizations.

She was an accomplished poet and one of the founders of the Poetry Society of Georgia. Sieg and a few others began reading poetry to each other in 1920s, and the poetry society established an award in her honor. (Courtesy of Daphne Murphy.)

Arthur Gordon

Arthur Gordon was the author of 14 books and many magazine articles. Gordon was born into a distinguished Savannah family in 1912, but he expanded his world far beyond Savannah. His great-grandfather W.W. Gordon brought the railroad into Savannah, and his aunt Juliette Gordon Low started the Girl Scouts. He attended Pape School in Savannah and boarding school and graduated from Yale University. He went on to Oxford University as a Rhodes scholar.

Arthur's first job was reading unsolicited manuscripts for *Good Housekeeping* magazine, a job he said "nearly blunted his literary teeth forever." He went on to become managing editor of the magazine within a few years. He wrote stories for many magazines and was the editor of *Good Housekeeping, Cosmopolitan,* and *Guidepost* magazines. He was the author of 14 books and contributed stories to *Reader's Digest, Esquire, Collier's, Saturday Evening Post,* and many other magazines. He retired to his hometown, where he and his wife, Pam, enjoyed summers at Tybee Island. He enjoyed his family, children, friends, and puttering around the inlet on a sunny afternoon. (Courtesy of Polly Cooper.)

Alice and Robert "Bob" Jepson

Savannah just got lucky in 1989 when Alice and Bob Jepson chose the city as their home. Many business executives have retired to the Landings, on the south side of Savannah, and many of them have contributed financially and as volunteers to the community. But nobody has hit the ground running like the Jepsons.

After college and military service, Bob Jepson formed his first company, in California. The first of many companies that raised money for other young entrepreneurs, Jepson's company made money for himself and lots of other people who took the risk that he knew what he was doing. He built one company after another, sharing his success with others and raising two boys with his wife, Alice.

As soon as they arrived in Savannah, both Alice and Bob agreed to serve on boards and volunteer their time and energy for the community. Coming here from Virginia, the Jepsons had given generously to the community they left behind. The University of Richmond is the beneficiary of the Jepson School of Leadership Studies, which opened in 1992. But they were just beginning.

The Jepsons believe that contributing to education will provide a lasting gift, and everything they have done in Savannah reflects that idea. The Jepson Center for the Arts is the most significant new construction in the city, and its glass facade invites visitors in to explore the concepts advocated by its parent museum, the Telfair Museum of Art, on the same square. The Georgia Historical Society boasts the Jepson Center across the street from its historical library. The Savannah College of Art and Design appreciates the Jepsons' contribution to its beautiful new museum of art, and there are many other less-visible projects that have become successful because of a little push from the Jepsons. (Courtesy of Alice and Robert Jepson.)

Paula Deen

Paula Deen is Savannah's celebrity that one would most enjoy spending time with. She was born in Albany, Georgia, in 1947, and came to Savannah with her two sons. In order to support herself and her family, Deen did what she knew how to do—she cooked. At first she made sandwiches that she sold out of her home, using her sons as delivery boys. Then she opened her own restaurant and became a tremendous success with her famous Southern cooking. Deen is now a celebrity chef and cooking show host with her own television network. (Courtesy of Paula Deen.)

Bruce Feiler

Bruce Feiler grew up in a family where his parents inspired him to strive for excellence. After Savannah Country Day School and Yale University, Bruce went to Japan and wrote a book called *Learning to Bow*. Then he joined the circus and wrote *Under the Big Top*. A total of 12 books, including *Abraham* and *Walking the Bible*, have been huge successes. Feiler lives with his wife and twin girls and has completed a series for PBS called *Sacred Journeys*. (Courtesy of Jane and Ed Feiler.)

Herb and Franklin Traub

Herb Traub was born in Savannah in 1918 and married Franklin Smith in 1953. He opened the Pirate's House that year, and the restaurant grew to 23 dining rooms that could seat 500 people. He employed 250 people there, giving many young Savannah people their first chance at a job. If one made a mistake, he would always give second chances. He also ran the popular Triple XXX and Our House on Victory Drive. Franklin collaborated on the first guidebook for Savannah to accompany the first tour guide service. Herb and Franklin had a lot of good ideas about how to improve the historic district, and they carried out many of them, including lighting the squares and the Talmadge Bridge and placing the fountain in Daffin Park. The Traub Award is given every year in their honor by the tourism leadership council to someone with a vision of what Savannah can be. (Courtesy of Kim Traub Ribbens.)

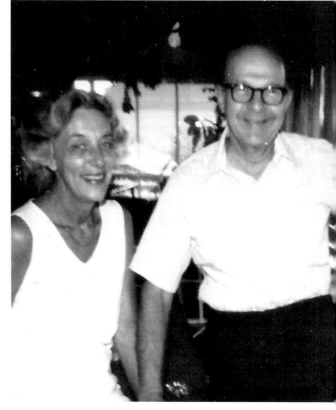

Alida Harper Fowlkes

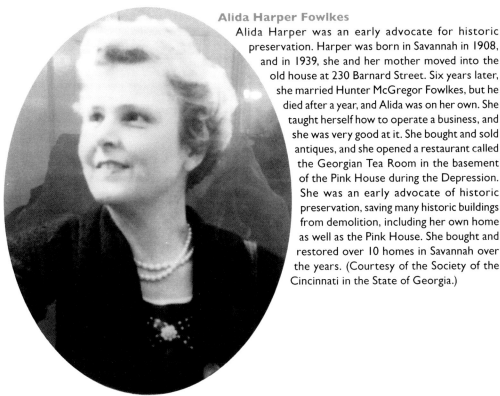

Alida Harper was an early advocate for historic preservation. Harper was born in Savannah in 1908, and in 1939, she and her mother moved into the old house at 230 Barnard Street. Six years later, she married Hunter McGregor Fowlkes, but he died after a year, and Alida was on her own. She taught herself how to operate a business, and she was very good at it. She bought and sold antiques, and she opened a restaurant called the Georgian Tea Room in the basement of the Pink House during the Depression. She was an early advocate of historic preservation, saving many historic buildings from demolition, including her own home as well as the Pink House. She bought and restored over 10 homes in Savannah over the years. (Courtesy of the Society of the Cincinnati in the State of Georgia.)

Alida Harper Fowlkes House

Alida lived in the old house for 45 years and saved it from demolition. Alida had always admired the handsome house on Barnard Street designed by Charles Cluskey when she rode by it on the streetcar. When she managed to buy it, she worked hard to earn money so that she could fill it with beautiful antiques. When she died, she left the house and all its furnishings to the Society of the Cincinnati in the State of Georgia to be used as state headquarters. She also left an endowment so that the house can be maintained for future generations. The house is visited by many tourists. (Courtesy of the author.)

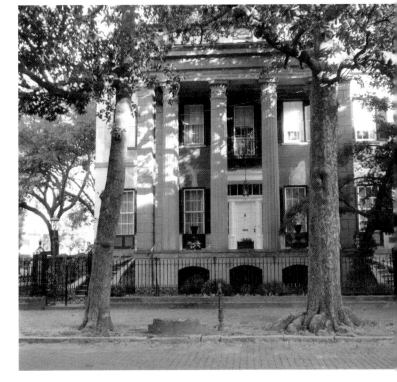

Frank W. Seiler

Frank W. "Sonny" Seiler is at home in court or in the movies. Seiler was born in Savannah and graduated from the University of Georgia and the University of Georgia Law School. He loved Athens, the UGA Bulldogs, and Sigma Chi fraternity; his future wife, Cecilia Gunn, was the sweetheart of Sigma Chi. Sonny was given a white bulldog while he was in law school, and the dog named Uga or one of his descendants has attended every football game played by the University of Georgia team. Sonny is now the senior partner of one of Savannah's most respected law firms, and Uga's portrait hangs on the wall with other honorable personalities. (Courtesy of Frank W. Seiler.)

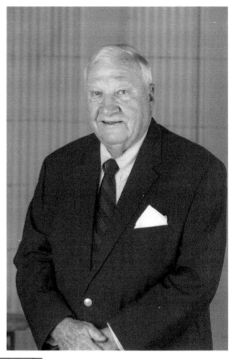

Alexander A. Lawrence

Alex Lawrence was a lawyer, speaker, historian, author, and federal judge. Lawrence was a prominent lawyer in Savannah before he became a federal judge, but he was one of Savannah's true legends. He was an author, a historian, and a talented speaker. He entertained clubs and groups with his funny stories and his unmatched intellect and wit. Once, as a young lawyer in the courtroom, he thought of an effective way to prove that his client should not be responsible for any harm caused to the woman who found a cockroach in her cola. He reached in his pocket and pulled out a roach, which he devoured in front of everyone, winning the case for his client. (Courtesy of Bouhan Falligant, LLP.)

INDEX